ART & COLOUR

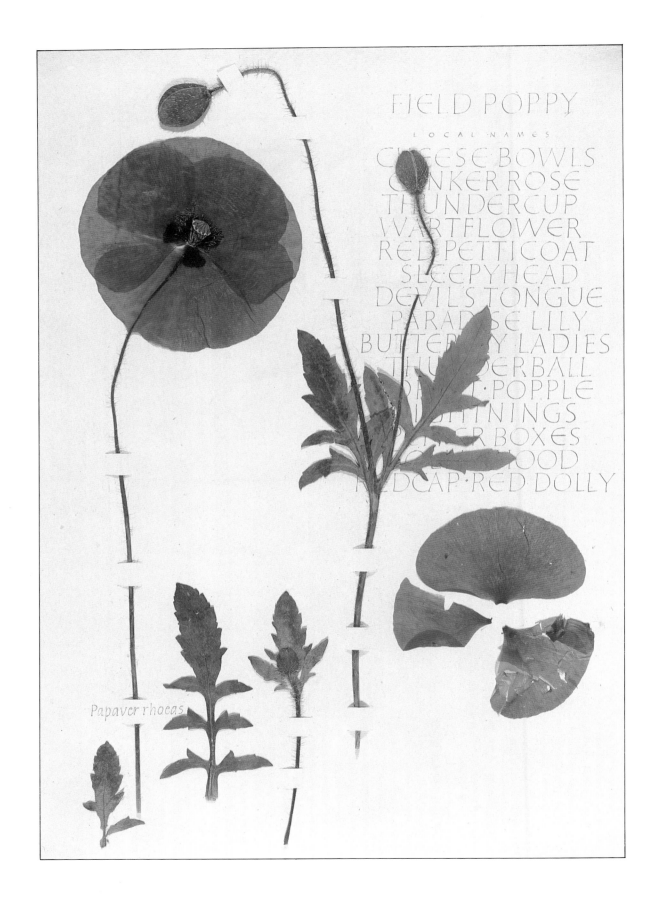

FIELD POPPY

LOCAL NAMES

CHEESE BOWLS
CANKER ROSE
THUNDERCUP
WARTFLOWER
RED PETTICOAT
SLEEPYHEAD
DEVIL'S TONGUE
PARADISE LILY
BUTTERFLY LADIES
THUNDERBALL
CORN POPPLE
LIGHTNINGS
PEPPER BOXES
COLLINWOOD
REDCAP · RED DOLLY

Papaver rhoeas

Calligraphy

ART & COLOUR

PETER HALLIDAY

B. T. Batsford Ltd, London

For Deanna

ACKNOWLEDGEMENTS

Thanks to all the artists who have given permission to reproduce their works; George Firmage for permission to use the work Poem 52 from *72 Poems* by E. E. Cummings (copyright 1963 Marion M. Cummings); Sue Cavendish and the Society of Scribes and Illuminators.

Thanks also to the following for permission to reproduce works in their possession: David Charlesworth (page 83); Margaret Gardner (page 57); Barry and Audrey Morgan (page 39); Professor Brian Veitch (page 77); Mr and Mrs K. Wollaston (page 68); and to Bennet, Lovatt & Associates Ltd., photographers.

First published 1994

Typeset by Latimer Trend & Co. Ltd, Plymouth

and printed in Hong Kong

Published by
B. T. Batsford Ltd
4 Fitzhardinge Street
London W1H 0AH

British Library Cataloguing-in-Publication Data.
A catalogue record for this book is available from the British Library.

ISBN 0 7134 6483 6

(Page 2)
'Flores Silvatici' with local names taken from *The Englishman's Flora* by Geoffrey Grigson. Hazel Dolby (UK), 35 × 25 cm (13¾ × 10 inches). From a book of pressed wildflowers. Gouache on Indian handmade paper. The very fine Roman capitals act as a delicate foil to the poppies

CONTENTS

INTRODUCTION

Calligraphy is an ancient craft and a contemporary art form. It is a means of communicating in a beautiful and artistic way that is both direct and accessible to anyone who appreciates words and has a respect for language. As the speed of our information-technology revolution gathers pace, calligraphy is gaining in popularity – acting as an antidote to the ever-changing demands of modern communication.

The invention of printing, in about 1450, could be described as the first information-technology revolution. For many centuries the only method of producing manuscripts and documents was by employing scribes to make them by hand. It is hardly surprising, then, that society soon embraced the new technology, allowing the technicians (printers) to assume the responsibility for reproducing the written word, and ultimately delegating the guardianship of our alphabet to their descendents (the graphic designers), along with the licence to do with it whatever they wish or is commercially expedient. The tradition of handwritten documents continued only in areas such as legal documents and grants of arms.

The disconnection from the methods of producing documents by hand continued when even everyday handwriting was learned from examples reproduced by engraved copperplates, where the engraver, using an engraving tool rather than a pen, dictated the changing forms of the letters.

Calligraphy was part of the wider Arts and Crafts revival continuing around the end of the nineteenth century, and was given its impetus by William Morris's earlier interest in manuscripts of medieval and Renaissance times. The revival of lettering and calligraphy, which has continued throughout this century, was spearheaded by Edward Johnston. He started a class in 1899 at the Central School of Art in London, where one of his first students was Eric Gill, the sculptor, letter cutter and type designer. Between them, and with the help of their students, they changed attitudes and very subtly influenced the shape of our alphabet, and by doing so helped to introduce some of our most familiar typefaces and letterforms.

So many developments and changes in attitude have taken place since the first revival that the link with the hand-produced manuscripts of medieval times seems tenuous indeed. But the link is there. There is the link of craftsmanship – the use of techniques and materials which have been researched and revived. There is, too, the link whereby the understanding of the words and the integrity of their interpretation are part and parcel of the calligraphic art. There is, however, a twentieth-century ingredient.

Many calligraphers today consider that their work is more of an art form than a strictly practical means of communicating information. After all, printers and graphic designers can do the job of basic communication with much greater efficiency, with their sophisticated machinery and computers. Calligraphers have re-established the link between the materials used, the purpose of the work and the understanding of the literary content. For this reason, more emphasis is now given to the work as an art object in its own right, rather than as a piece of craft work acting as a vehicle for the subject matter, with the concentration on the technical craftsmanship.

There is, however, a dichotomy. Throughout this century, calligraphy has developed very much as a craft, particularly in Britain. The reasons for this lie primarily in its roots in the craft movements of the early twentieth century and the philosophy of William Morris's followers: the craft object becomes

an art object through the integrity of the maker and the appropriate use of materials. When this philosophy is followed, with the consequent search for perfection, much calligraphy can begin to look like printing. So the question is: why try to do something that a printer or a desk-top-publishing package can do better? The answer is increasingly that calligraphers don't, while the more accomplished ones never did.

Calligraphers delight in the meanings of words and in the use of materials, and often the choice of words will influence the choice of materials and the way in which they are used. It could be said that all you need is some paper and a pen, and, in a way, that is all you do need. You could go out and buy a calligraphy pen set or a few fibre-tip pens, some writing-paper and a book of your favourite poetry, and away you go! This would soon become boring and limited in scope, however, as you will need a knowledge of the formal procedures and techniques, just as you would with any other art or craft.

The traditional writing surfaces are vellum (or parchment) and fine papers. Vellum is the material of the ancient manuscripts, such as the Book of Kells, the Domesday Book and the Magna Carta. It is, and always was, expensive, but is still used by calligraphers today because of its unique properties of permanence, its magnificent colour and the way in which ink and colours are enhanced by the multi-layered nature of the skin. It is also possible to scrape off mistakes – a very useful property, as mistakes and omissions are an affliction from which calligraphers often suffer. (Even Chaucer had to complain to his scribe that: '. . . you deserve to get the scab under your long hair unless you copy more faithfully what I compose so often do I have to redo your work'.)

Handmade papers are greatly prized, and, although the variety of such papers is much reduced today, it is still possible to obtain the leftovers from a previous era and to delight in their unique qualities. Today we use a mixture of good mass-produced papers and beautiful handmade papers such as those still made in India and Japan. Many modern papers are handmade, but what calligraphers look for are properties of durability and a fine-quality surface.

The ancient methods researched by the early twentieth-century pioneers are never used for quaintness, but only where their use is important for the effect and where no other methods are appropriate. Modern materials and methods can be used. Acrylic and PVA media are used to bind pigments, to enhance their brilliance and to introduce some water resistance so that overpainting effects may be used. Almost all watercolour-painting and art techniques can be employed in calligraphic work, including the use of resists, crayon, pastel, pencil and coloured felt-tip pens. Although the edged pen is still the principal writing tool, any mark-making instrument that is consistent with the subject matter can bring special qualities to calligraphic work.

During the last fifteen to twenty years, a second calligraphic revival has been taking place. With the special talents of scribes such as Donald Jackson and Ann Hechle, and a decision by the Society of Scribes and Illuminators in England to promote part-time classes, calligraphy began a grass-roots revival which also started in the United States assisted by Donald Jackson, Ann Hechle, Ieuan Rees, David Howells and other Britons. This revival in America took off in a big way, assisted by American calligraphers and Sheila Waters, a Briton living there, and today some of the finest calligraphers are those who live and work in North America. The involvement of German calligraphers, including Hermann Zapf, Werner Schieder and Karl-Georg Hoefer, in the United States further enhanced the growing art. The new revival is spreading throughout the English-speaking world, and is also moving into Scandinavia and other European countries, where work of originality and flair is being produced by young and innovative calligraphers.

Calligraphy is a growing art, and is worthy of attention from all who have any interest in the arts in general, and all who have an interest in words. This book sets out to instruct and educate the reader in ways of making letters with pens, as well as placing emphasis on areas such as colour interpretation and experimentation, which have not often been emphasized in other publications. As an art form, calligraphy has few limitations and a multitude of directions; as a tool for graphic design, it has a scope and inventiveness against which type alone can never compete.

Peter Halliday

DIFFERENT ALPHABETS AND HOW TO USE THEM

PATTERN

Each calligraphic style creates a different kind of pattern, and so pattern-making is an essential basis for learning and practising calligraphy. Although evenness and consistency are important, making an absolutely perfect letterform every time is not only impossible but undesirable, as the result would be more like printing than writing, and would lack the individuality of a sensitively created work of craftsmanship. Letters should look consistent, as the leaves on a tree are consistent, but must vary according to the context and purpose of the work.

The regular and rhythmic movement of the pen creates a pattern, but to judge this in a completely objective way is not easy at first. Looking at any lettering or calligraphy as a pattern, without reading it, is quite difficult. Reading becomes a reflex action, and, to the innocent 'man in the street', the importance of form and spacing has a low priority unless the lettering is so inexpertly done or badly spaced as to interfere with

legibility. In this case he may not understand why it seems wrong, but just knows that something *is* wrong. Good form and spacing, on the other hand, do not usually draw attention to themselves.

To be good enough 'not to be noticed', sound examples must be studied and learned. Frequent and purposeful practice needs to be carried out, because pattern-making (creating regular letter shapes) depends on repetition as well as critical development. The form and kind of practice will vary according to the writing implement being used, and the style or letterform being studied.

Practice for its own sake, however, is not a good thing at all: a purpose and aim need to be established at the start. For example, it may be an enjoyable and even highly skilled task to make a detailed copy of a historical manuscript, but if that is an end in itself and nothing is learned from it, then it is a sterile activity which only teaches us to copy. If, on the other hand, the aim in making the copy is to discover the way in which the colour was used, or the importance of pattern variation so that its

essence may be introduced into original design work, then the purpose is a good one and should be carried out with as much expertise as possible.

ALPHABET FORMS

We recognize many different versions of the alphabet today, but the forms do not vary a great deal in essence, or they would be impossible to read. Letters which did not conform to any convention at all would simply not make sense. This need to conform means that, although alphabets do vary, the basic structures cannot be too eccentric.

Development of our letterforms has taken place since Roman times and even earlier. The forms that we use today, however, can be narrowed down to three basic ones: Roman capitals, lower case (half uncial) and italic (from the fifteenth century). Other variations have taken place over the centuries, including changes in everyday handwriting.

With two thousand years of variations from which to choose, it can seem an impossible task to

'Alphabet' by Gaynor Goffe (UK), 150 × 80 cm (59 × 31½ inches). Ink, gouache, automatic pens, nibs and ruling pen. The main alphabet was written with an automatic pen. The multi-stroke capitals and single-stroke alphabet were written with a ruling pen

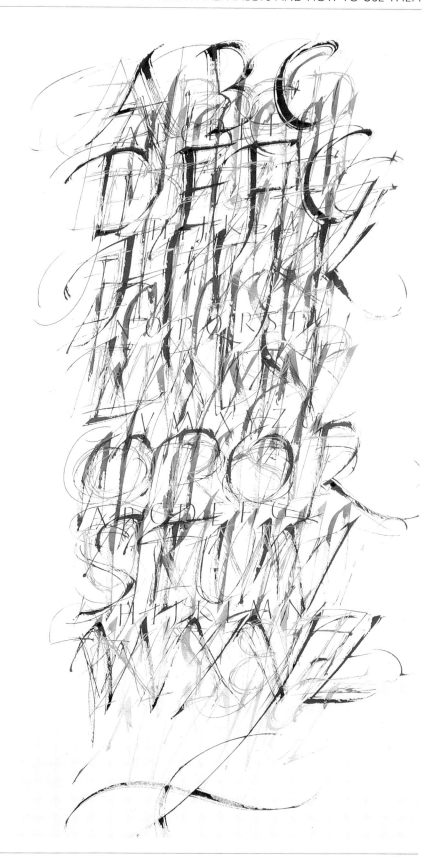

select any particular style or form. The sensible answer is to make our aims clear and select accordingly. Drawn letters are dealt with later on (see Chapter 8), so our first action is to look for calligraphic letterforms which are not difficult for modern eyes to read, and then to look for the style or fashion suitable to any particular work. It is very hard to make these judgements without some inside knowledge of what makes a letterform work, so it seems sensible to look at the dynamics of the various alphabet forms at our disposal, and the influences on them.

There are three main factors governing calligraphic form. These are: the proportion of the letterform, the type of writing tool used, and the ductus (the direction taken by the writing tool).

The most important of these is the proportion, or correct shape, of the letter. No matter how the letters are dressed eventually, the basic shape (sometimes called the skeleton) must conform to a proportion particular to a specific style. The letter 'O' is the chief guide to the proportion, and the rest of the alphabet follows this shape.

The type of tool used has a direct influence on the way in which the proportion is made to work. The size of the letter in relation to the width of the letter

stroke has an important modifying effect, and, if an edged tool is used, the angle that the pen is held at to make the stroke will modify the form further. The shape of the serif or the starting and finishing stroke will also give the letter a stylistic variation. Calligraphic form is subject to so many subtle influences that it is little wonder that it

takes time and critical awareness to make good letters.

The ductus, or directional movement of the writing tool on the surface, will modify the letter even more. Speed, freedom and the degree of tension in the hand and body can change the 'feel' of the writing, and confidence can also have a decisive effect.

Pen forms. Notice how the combination of pen angle, letter height and letter width changes the appearance of the letters quite radically. The writing instrument also has a considerable effect. I created these examples with pens (both edged and pointed), pencils and crayons

EXPERIMENT 1

When you have looked at the examples shown here, select four different kinds of writing tool (for example, an italic felt-tip pen, a calligraphy pen, a pencil and a crayon), and make copies of the patterns. Just make rough trials on practice paper at first, and don't worry about false starts and mistakes – gain confidence by trial and error. Gradually increase the amount that you can write without stopping, and then concentrate on making it as even as possible.

Try half-a-dozen different patterns using the four writing tools. Try to work without stopping, eventually, only pausing occasionally but not stopping altogether.

When you are proficient enough to be able to make patterns with confidence, you should be ready to make a 'carpet' pattern such as the one illustrated. Start with a thumbnail sketch in pencil and then get going – don't practise for too long. Try to get your designs completed and then go on to improved, finished versions.

(Below left)
A garage door, which I have used as the basis of the pattern design below

(Bottom left)
View of a weathered stone wall, used as the starting point for the pattern design below

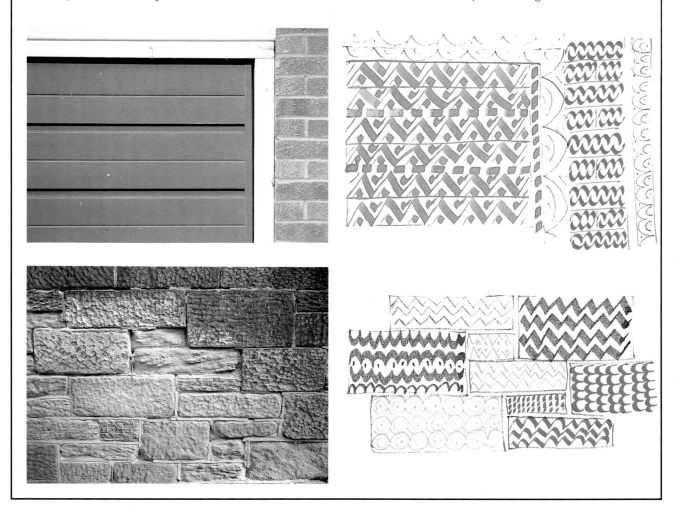

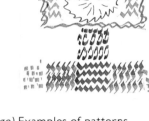

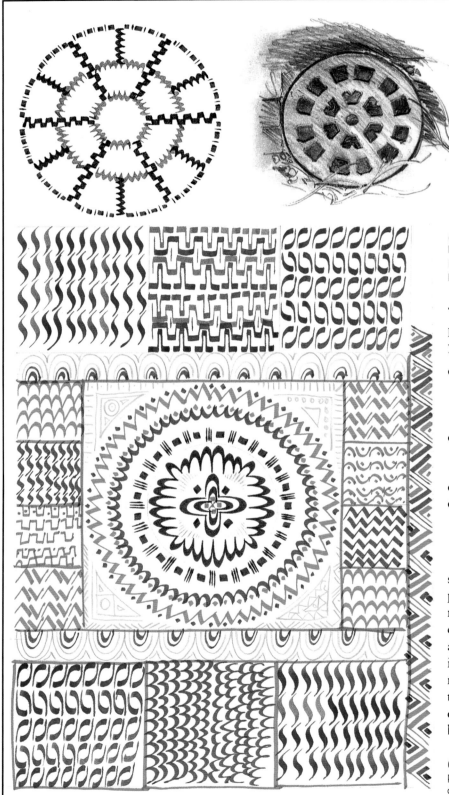

(This page) Examples of patterns based on objects observed in the local area, which I have used as a basis for making a carpet page

The following are some points to think about while you are working:

- work in comfort with your paper in front of you while you sit square at the table or desk
- aim ahead: work by looking toward the space that you are going to fill
- use guidelines if you wish
- hold your writing tool comfortably and not too tightly

Take inspiration from your surroundings as often as possible and start to draw – not to become expert in drawing, but to learn to look around and gain visual information *for your own use*, not necessarily for others to see. Look at a wide variety of subjects, such as plants, buildings, fabrics and animals.

(Opposite) The finished carpet page, carried out with pens and coloured pencil crayons

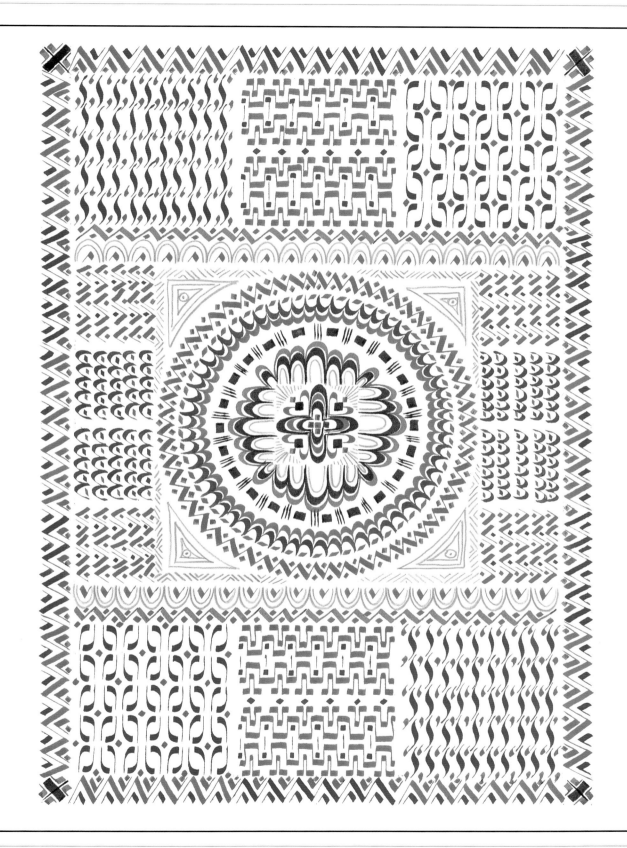

EXPERIMENT 2

Look at the different alphabets illustrated in the book. Choose one of them and, with a pen, felt-tip or pencil, make the shape of the letter 'O'.

Repeat the shape consistently, in a line. Try making the shape with the other tools that you have, and note how different they look and feel when you make them.

Next, select a calligraphy pen which will make the 'O' seem the right size and shape. Look particularly at the inside of the letter, known as the counter, and try to make *that* shape every time you write the 'O'. Pay particular attention to the pen angle and make sure that you keep this angle constant for the style that you have chosen. You will need to work by trial and error, and, when you think that you can make the shape fairly consistently, rule some parallel lines at the correct height and practise by making a pattern line of consistent 'O's.

To become proficient in your chosen style, you will need to do quite a lot of basic practice so that you can make the letters consistently good without hesitation. The movement has to become as automatic as possible. One way of practising is to rule feint pencil lines to the height of the 'O's all the way down an A3 layout pad, and then to write *one line only* of each letter of the alphabet. Don't be tempted to write more than one line of each at this stage, as you may get stuck on a letter which you think you can't do. Wait until you have worked your way through to 'Z', and *then* try the ones which seemed more difficult. You may be surprised to find that they are easier than you thought, and you will probably have saved some time as well.

EXPERIMENT 3

When you have practised enough to be able to make the letters fairly consistently, design a carpet page such as the one illustrated here.

Draw out a plan in rough first, and try fitting all the letters of the alphabet into the design in the best way possible. When you are satisfied that the design will work, rule up another, final design and write it out. If you are using a layout pad, you can probably lay the paper that you are using for the final design over the rough so that you can see through and use it as a guide.

Many other patterns and designs can be made in this way, using colour and variations of letter size to introduce variety (see page 36 and Chapter 5 for uses of colour). Using words for your carpet design is useful, too, as it will help you to begin using letters to create word units, and to start thinking about spacing.

I worked this carpet page in a combination of italic fibre-tips and dip pens with black and coloured inks

PROJECT *Calligram*

Using calligraphy in a purely decorative way is nothing new; medieval scribes often turned their work into decoration or tongue-in-cheek ideas. For this project you will need either to draw a basic idea, or to find a simplified picture from which to work. A simplified animal or bird shape would do, or you could use a more complex shape. It depends upon how ambitious you wish to be.

This calligram project is a development of the exercises carried out earlier (see pages 11 and 14) to establish rhythm and pattern. You will probably need to try out your idea two or three times before you embark on the final version. This is quite normal when designing for calligraphy, because of the spontaneous nature of the mark-making – you can't go back and make corrections without spoiling the clarity of the letter shape.

Carry out your design on paper no smaller than A3 size ($16\frac{1}{2} \times 11\frac{3}{4}$ inches). Making it smaller may seem better, but for this project you need to be able to make the letters as accurate as possible, and this is best done on a larger scale (larger than A3 if you prefer). Although a thumbnail sketch is a good idea as a starting point, once the idea has been sketched out you should work full-size. This is because changing the pen size has the effect of altering the feel and proportion of the letters, and also the whole design.

The words for a calligram must be in the nature of a pun. They need to convey the idea, or simply name the part which the words cover. So the wing of a bird could be filled in with the word 'wing', and so on.

Start quite roughly, so that you can establish where the size should be altered or the letterform simply distorted. Where the size changes significantly, you must change the size of the pen accordingly (see illustrations). Remember to judge the size and proportion by looking at the counter (the inside) of the letters. Work in one colour to begin with, and introduce other colours once the design is settled.

The calligram should fill the space comfortably, and, as composition is important, this is an aspect which needs to be considered from the initial design stage.

Making calligram designs with different mark-making tools, and varying patterns and letterforms according to the tool, will demonstrate the important effect that each has on the letter shape. Always make sure that you keep to the essential form of your chosen style – the skeleton form must not vary too much, and the family likeness of the alphabet must be retained.

(Opposite, left)
A heraldic eagle acted as an ideal formalized bird form for this calligram. I began by making a pencil drawing of the eagle's outline and experimenting with the lettering

(Opposite, right)
I carried out the design in coloured inks, using the original pencil drawing under the rough paper to act as a guide

(Opposite)
The finished calligram. I used dip pens and designers' gouache for this final version

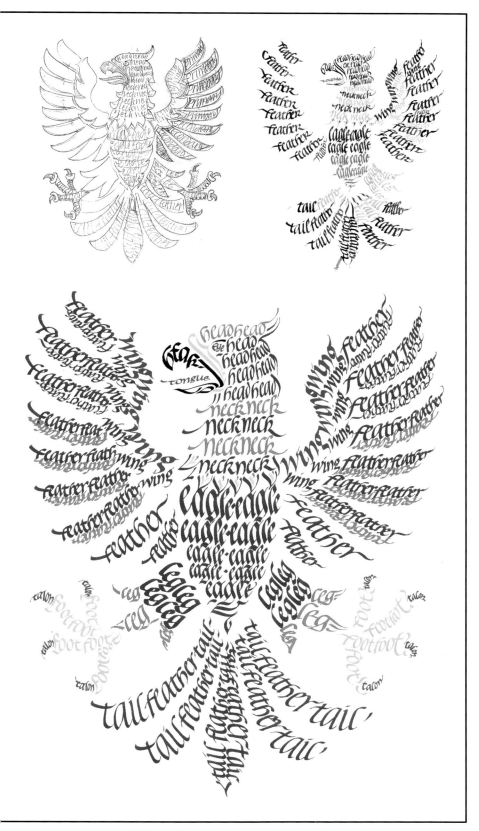

USING DIFFERENT ALPHABET FORMS

Making patterns and inventing calligrams are good ways of becoming familiar with the mark-making tool and the rhythm of the particular alphabet being used. The effect is always decorative and attractive, but to control and use calligraphy as a communicating medium requires more disciplined work and a deeper understanding of the different alphabet styles.

As there are so many different styles from which to choose, it may be difficult to know which is the correct one to use. Looking for styles which suit the work being done, and making a selection on the basis of the following is a good way to start:

- is the style easy to read?
- can the style be used in different ways (size, weight etc.)?
- is it pleasing and in keeping with the work?

To make these kinds of judgements, you will need to spend some time putting the styles to use. Looking at examples of their application by experienced designers would be helpful.

Italic

This is probably the most-used calligraphic letterform. It has its beginnings in the fifteenth century when the style was first adopted by the Papal Chancery, and in fact is often known as Chancery cursive. In printing work, the word italic means sloping forward, but in calligraphic use it is the specific name for the style.

Italic is the most adaptable form in use, and can be written as a

abcdefgghijk l mnopqorstuvwxyz

abcdefgghijklmnop

symphony

oa

PEN ANGLE

·BASIC FORM·
·OVAL·

×4½-5
APPROX.

PEN
PROPOR
TION

Chancery Cursive
Humanistic ~
~ Cursive

Italic

ABCDEFGHIJKLM
NOPQRSTU
VWXYZ

R

·ARRIGHI·TAGLIENTE·PALATINO·

Pater

aABCDEFGHIJ
KLMNOPQR
STUVWXYZ

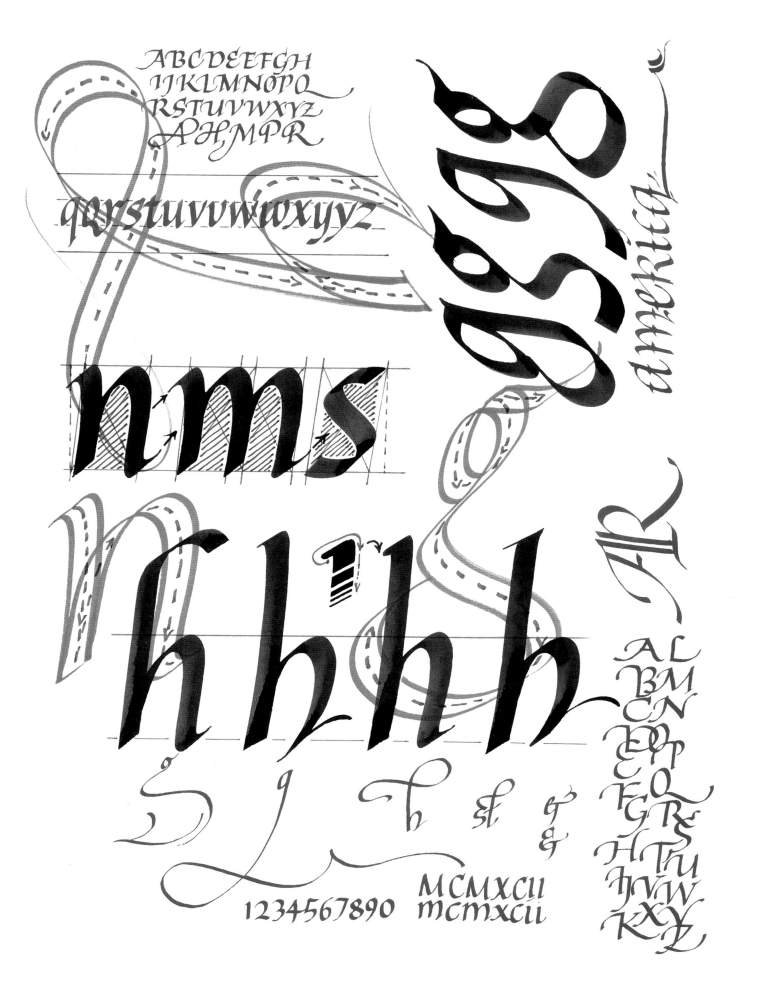

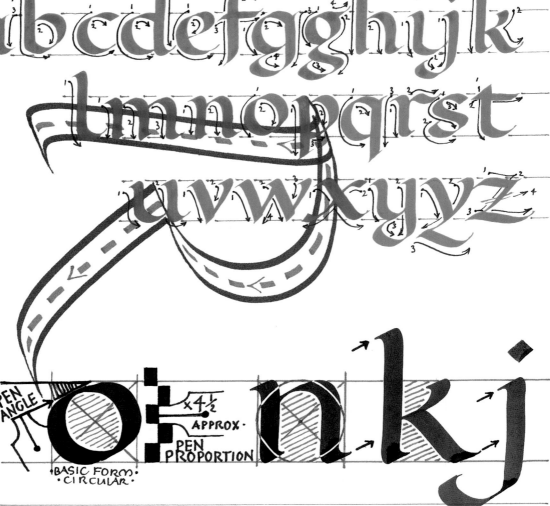

aabbcdefgggghijk

lmnopqrst

uvwxyyz

o: nkj

PEN ANGLE
×4½ APPROX.
PEN PROPORTION
BASIC FORM · CIRCULAR ·

ABCDEFGHIJ

OPQRSTUV&

CAROLINGIAN HUMANISTIC

ABCDEFGHIJKLMNO
abcdefghijklmnopqr

abcdefghijklmnopqrst
uvwxyz Carolingian

Round Hand

& two
related
hands

ght

ROUND HAND

KLMN-
WXYZ &.,?!&

PQRSTUVWXYZ
stuvwxyz Humanistic

formal style or with degrees of informality – even as a kind of formalized personal handwriting. Copperplate writing styles are derived from italic. Although copperplate is a style which may be drawn, as well as written with a pointed, flexible pen, italic is essentially a written form. It can be carried out using any kind of point or brush, but is best characterized to begin with by using an edged pen. Italic is usually written fluently with few pen lifts, and the pen is pushed as well as pulled.

Roundhand

Roundhand is the name often applied to the style based on the Carolingian text form used between the eighth and eleventh centuries, and the Humanistic style of the fifteenth century, which was also derived from Carolingian. Roundhand is a formal hand, in which the pen is always pulled to make each stroke and frequently lifted in the writing of each letter.

Roman printing type used for text was originally copied from the fifteenth-century Humanistic form. Edward Johnston revived the tenth-century English form of Carolingian in the early years of the twentieth century and called it foundational hand; he used the style as a 'foundation' in his teaching, and many present-day calligraphers have been taught this as their first hand.

Gothic

Gothic is sometimes known as blackletter, and is based on the compressed book hands of the twelfth to the fifteenth centuries. Fraktur is also a gothic hand, and is a handwritten form of German gothic printing type from the fifteenth century. The style is formal, very compressed and dark in texture because of the closeness of the pen strokes. The first printed books of Gutenburg were made as copies of gothic manuscripts, although the more elegant and legible Roman type soon became the norm as printing developed.

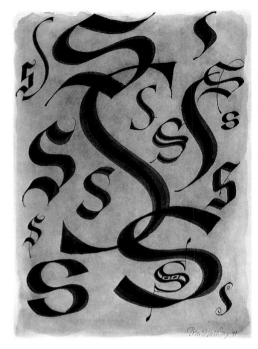

'A page of S's' by Peter Halliday (UK), 41·5 × 29·5 cm (16 × 11½ inches). Chinese ink on rough paper. I created this piece by writing with pens of decreasing size, layer on layer, and scrubbing the surface with water between each application. There are different kinds of alphabet here; notice how the pen angle has been twisted or manipulated in the writing of each stroke

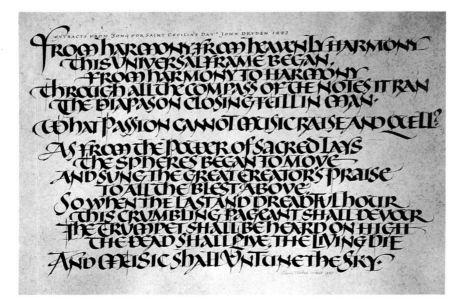

'From Harmony . . .' Extracts from 'Song for St Cecilia's Day' by John Dryden, 1687. Sheila Waters (USA), 48·2 × 63·5 cm (19 × 25 inches). This magnificent example of a modernized uncial was written with Chinese ink on handmade paper

Uncial

The uncial style was first used around the third century, and it continued in use, in subsequent forms, until the twelfth century. It is a majuscule alphabet, having neither capitals nor lowercase letters, which has characteristics from both Latin and Greek alphabets. Although an ancient form, it is suitable for the most modern applications after some modification.

Pen angle

The angle at which the pen makes a thin stroke when writing is called the pen angle; this is usually constant. Some alphabet styles can allow a certain amount of manipulation. An experienced calligrapher will subtly manipulate and change the pen angle when working, but the importance of maintaining a constant angle needs to be understood before being too adventurous.

'The Communion Service' by Peter Halliday (UK), 62 × 67 cm (24½ × 26½ inches). Written with goose quills in Chinese ink and blue and vermilion watercolour, with the addition of raised and burnished gold, on unstretched vellum.

The main text is in roundhand, with some writing in a formal italic and a modern Roman. Compare this with the examples on pages 59 and 60, and notice how the textural masses are varied to allow the piece to be appreciated from varying distances

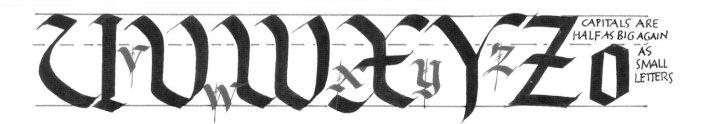

CAPITALS ARE HALF AS BIG AGAIN AS SMALL LETTERS

abcdefghijklm

nopqrst...

ABCDDEFGHIJK

LMNOPQRS

ALTERNATIVES

FPRY TUVWXYZ

CEFGSL

PEN
ANGLE

of

4X
APPROX.
PEN
PROPORTION

·BASIC FORM·V·ROUND·

phe

·GIVE ALL LETTERS GENEROUS SPACE·

ABCDEFGHIJKLM

NOPQRSTUVWX

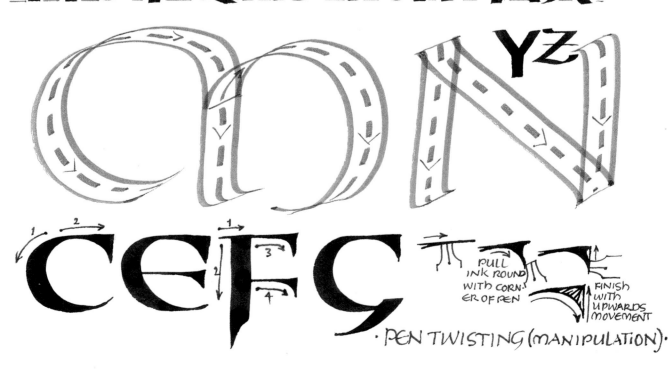

YZ

1 2 1
CEFG 3
 2
 4

PULL
INK ROUND
WITH CORN·
ER OF PEN

FINISH
WITH
UPWARDS
MOVEMENT

·PEN TWISTING (MANIPULATION)·

UNCIALS WERE USED IN VARIOUS FORMS FROM
THE LATE ROMAN PERIOD (4th CENTURY) THROUGH TO
THE 13th CENTURY WHERE THEY APPEARED TO FORM THE
BASIS FOR 'VERSAL' CAPITALS, USED FOR ILLUMINATED CAPITALS

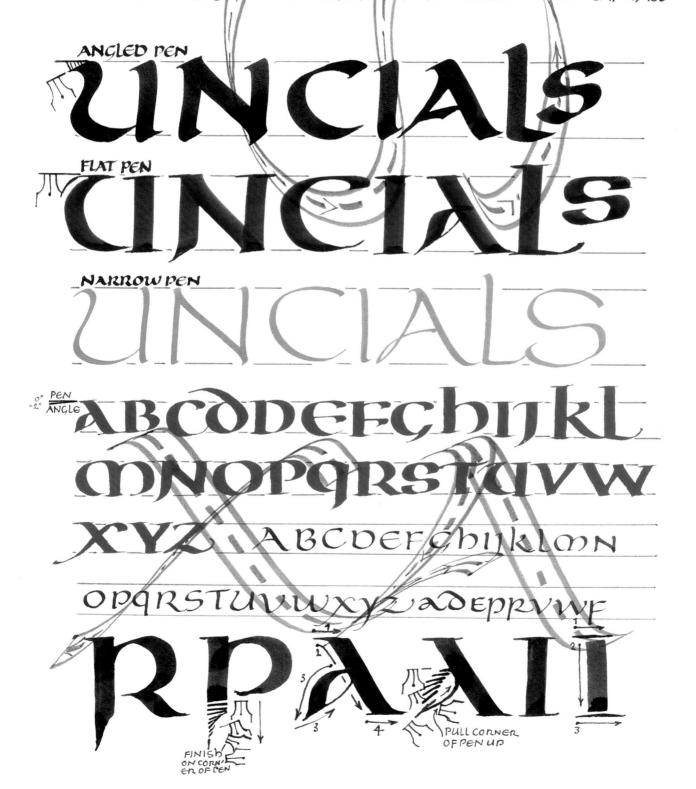

ANGLED PEN

UNCIALS

FLAT PEN

UNCIALS

NARROW PEN

UNCIALS

0° PEN
-2° ANGLE

ABCDEFGHIJKL

MNOPQRSTUVW

XYZ ABCDEFGHIJKLMN

OPQRSTUVWXYZ adeprvwf

RPAAII

FINISH
ON CORN-
ER OF PEN

PULL CORNER
OF PEN UP

Spacing. In the various versions of the word 'minimum', notice how the counters and spaces are largely very similar. This is the ideal for which to aim in your calligraphic writing, although compromises always intervene.

The words 'try' and 'straight' are shown in two versions: firstly without any attention being paid to spacing, and then in a version showing the way in which letters are adapted to one another to make them read as 'word units'. The arrows show the most important points at which I have made adaptations and variations. Avoid compromising the counter of any letter. If you follow this rule, the letters will always 'read' well

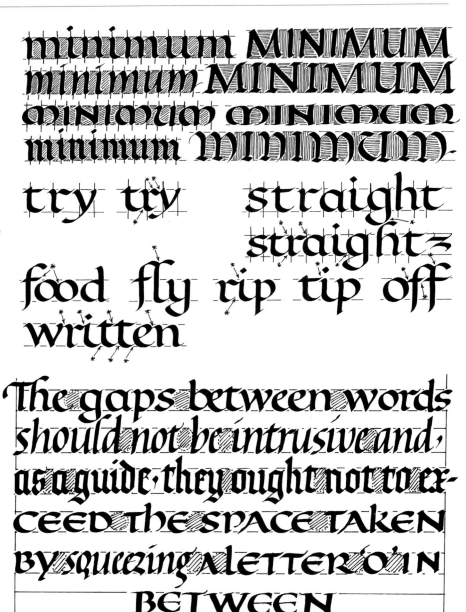

Spacing

Any piece of lettering will look better if it has good spacing. The spacing of calligraphy is something which needs to be worked on gradually. It has much to do with rhythm when writing, awareness of pattern and the ability to see the counters and spaces between letters as negative shapes around the letterforms. Each letter, as it is

written, is affected both by its predecessor and the letter to follow. Spacing is not a matter of measurement, but of judgement.

Look at the examples shown above, and note the starting points of the various letters and the way in which some letters are allowed to touch – but not bump into – each other. In other instances, letters are joined by ligatures. The letters should not be distorted to

make them fit. The ultimate aim is to create words as complete units; after all, we read words as shapes and not as a series of individual letters, and the spacing should emphasize this fact. The gaps between words should not be intrusive and, as a guide, they ought not to exceed the space taken by squeezing a letter 'O' in between. See page 37 for further information on spacing.

2

TOOLS AND MATERIALS

Each tool, or mark-making implement, will give any particular piece of lettering or calligraphy a special character. Throughout history, the development of the alphabet has been influenced by the way a particular tool has been used.

Any student of lettering has to find out how the tools at his or her disposal can be best used to create the most effective result. I include in the list of 'tools' computers and video, as well as the process camera. Any designer of lettering will be called upon to design and work with these as well as with the more conventional, hands-on tools such as brushes and pens.

All lettering, however, starts with the co-ordination of mind and hand, and the best way of understanding how and why letters do their job is actually to make letters in the most direct way

Different writing implements will produce a wide range of effects, as shown in this illustration. Sometimes the use of the pen has to be adapted to form the letter, and sometimes a particular letterform must be selected to suit the chosen implement

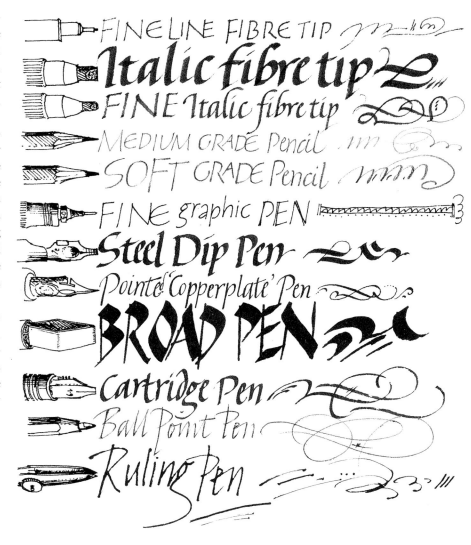

possible: this means using pens and brushes for calligraphy and pencils for drawing letterforms which are not directly calligraphic.

PENS AND BRUSHES

In calligraphic work, the pen or brush is the direct tool which makes the finished letter – the work is immediate as well as direct. With a pen or brush you see the letterforms growing as you work, and, as you will have discovered when trying out the different calligraphic alphabets, once you have made your mark there is no going back. Your commitment is not only direct but final, and for this reason the choice of writing implement is crucial.

It would be imprudent, to say the least, to use the same pen for doing a quick notice as for writing the most exquisite scroll for an important patron. The former might be carried out with a felt-tip pen which needs minimal sensitivity; the latter might be done using a quill pen which needs great sensitivity as well as considerable cutting skill in the first place.

Our Western alphabet has developed through the use of an edged writing implement. The inscriptions of Roman times were probably laid out, before they were cut into stone, by being painted with a chisel-shaped brush, or written with a reed pen. When, as in the later Roman period, the Christian gospels were copied and re-copied, they were written out using reed and quill pens cut to a chisel shape. This use of writing implements of a particular kind set the eventual shape of our alphabet and, to a large extent, the way it was written.

It is clear that a pen of a certain shape will make letterforms with particular characteristics. Modern technology enables us to make and use pens which will write instantaneously, and which will move easily in any direction without the problems encountered with traditional pens when pushing them rather than the usual pulling.

From the *Manuel Typographique* of
Pierre Simon Fournier, Paris, 1764

Après les choses
AFTER THE BASIC
qui sont de
NECESSITIES
première nécessité
OF LIFE
pour la vie,
NOTHING IS
rien n'est plus
MORE PRECIOUS
précieux que
THAN BOOKS
Les Livres

To Don and Monique, December 1988

Sheila Waters scripsit

'Après les choses . . .' From the *Manuel Typographique* of Pierre Fournier (Paris, 1764). Sheila Waters (USA), 30·5 × 22·7 cm (12 × 9 inches). The writing of the main text in this example is in a form of writing called 'bâtarde', and is in Indian red gouache with the translation alternating in black written Roman capitals. The surface is sheepskin parchment

EXPERIMENT 1
To note how the pen influences the letterform

Write out a short phrase as many times as you have different pens. Use two different styles, such as uncial and gothic, and try to make the writing look as close to the style as possible. Notice the way in which the letters and spacing are influenced by the pen width as well as by the pen itself. Whereas uncial may be effectively adapted when using a ball-point pen, for example, gothic is far less likely to work as it relies on the thickness, texture and contrast of the pen stroke.

Note: the rules of spacing should not be abandoned in any way for this experiment.

In this example the writing is mostly uniform in size, but varying the size will also have a marked effect on the outcome. The variations are almost innumerable

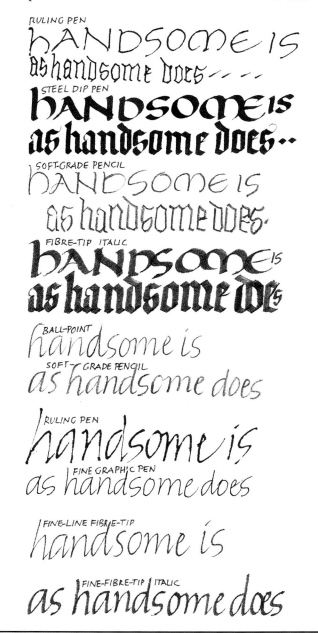

EXPERIMENT 2
To understand contrasting qualities of letterform and pens

Once again, use two different styles, this time chosen for their contrasting qualities, such as italic and Roman capitals. Select a pen which makes a narrow mark for the capitals, and a broader pen for the italic. Write out your short phrase or saying using alternate lines – capitals then italic – making the capitals tall and slender and the italic broad and showing plenty of contrast.

This illustrates the contrasting qualities of letterforms. The use of Latin in compressed-pen written Roman and the translation in a strong formal italic enhances the contrast

OMNES ARTES QUÆ AD HUMANITATEm PERTINEN
all arts which have anything to do with man
HABENT QUADDAM COMMUNE VINCLUM ᴱᵀ QUASI
have a common bond & as it were, contain
COGNATIONE QUADDAM INTER SE CONTINENTUR
within themselves a certain affinity·

·MARCVS·TVLLIVS·CICERO· 106–43 BC

SURFACES

It is, of course, possible to write or letter on almost any surface, and calligraphers and lettering artists are often asked to apply lettering to a variety of differing surfaces from brickwork to plastic sheeting, wood, metal and glass.

Each surface has its own particular qualities, and each job will have its special considerations as to prestige and durability. Apart from the considerations of good taste and elegance, the choice of proper materials appropriate to the job is of prime importance.

Papers

Papers used for calligraphy generally need to be fairly smooth and non-porous. As most calligraphy is carried out in ink or paint, you must be confident that the paper will not absorb the ink and allow it to spread as if it were blotting paper. You will find as you progress that rough and absorbent papers may be used, but they do require the care achieved through experience.

The paper in layout pads is usually suitable for design work and practice. It tends to be thin, smooth and non-absorbent, but is also bland and uninteresting with very little character, and would not normally be used for finished work unless it were for a paste-up (see pages 43 and 47). Cartridge paper varies a good deal in smoothness

(Opposite)
'Old Shaker song' by Peter Halliday (UK), 34 × 24·5 cm (13½ × 9¾ inches). Soft pencil on American handmade paper. I wrote this small piece out in a way which allowed easy photocopying with the paper texture showing through on the print. The copies were to be given out to those watching a dance sequence to the music of Aaron Copeland's 'Appalachian spring'

'TIS THE GIFT TO BE SIMPLE
'TIS THE GIFT TO BE FREE
'TIS THE GIFT TO COME DOWN
WHERE WE OUGHT TO BE
AND WHEN WE FIND OURSELVES
IN THE PLACE JUST RIGHT
'TWILL BE
IN THE VALLEY
OF
LOVE
AND
DELIGHT

✝

OLD SHAKER SONG

PLH '89

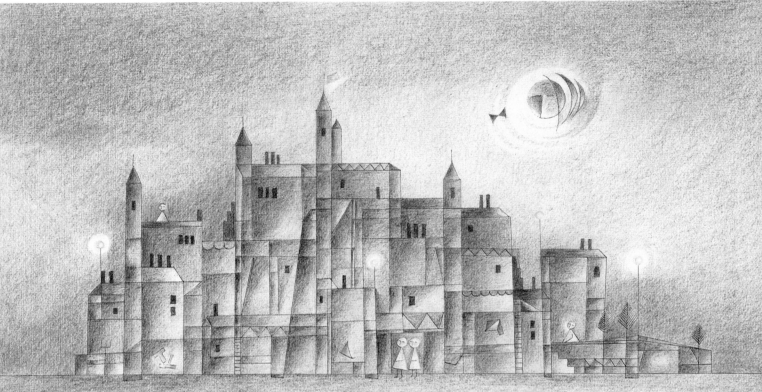

*WHEN THE NIGHT WIND HOWLS IN THE CHIMNEY'S COWLS AND THE BAT IN THE MOONLIGHT FLIES
AND INKY CLOUDS, LIKE FUNERAL SHROUDS, SAIL OVER THE MIDNIGHT SKIES
WHEN THE FOOTPADS QUAIL AT THE NIGHT-BIRD'S WAIL, AND BLACK DOGS BAY AT THE MOON *
THEN IS THE SPECTRE'S HOLIDAY * THIS IS THE GHOST'S HIGH NOON

THE GHOST'S HIGH NOON W.S. GILBERT

'The Castle' by Brian Walker (UK), 24 × 40 cm (9½ × 15¾ inches). Chinese ink and coloured pencil on Daler Whatman 140 lb (300 gsm) paper. Brian Walker explains this piece as follows.

'Having had three children and taught thousands more over a thirty-year span, I decided to draw on this experience and do a piece of calligraphy which echoed this interest in children. In addition, I wanted to combine calligraphy with my art-teaching experience by using non-figurative forms such as horizontal and vertical lines, points in space, space and colour. The coloured pencil was applied lightly in several layers. There is a Cubist influence in the way each shape is shaded. The lettering is essentially skeleton Roman capitals to echo the simplicity of line in the drawing; the subject matter is dramatic to reflect the words in the poem. Also, though, look for the humour.'

EXPERIMENT 3

Take a mixing palette, an egg cup, or any small container, and squeeze some designers' gouache into it (about a pea-size squeeze will be enough). Gradually add water and mix with a clean brush until all the paint is mixed into the water. The consistency should resemble single cream, so that it is dense enough to cover the paper, but thin enough to flow smoothly as you write.

Select a pen which will write the letters about 1 cm (½ inch) high, and write a few letters on some trial paper.

Draw a square with sides approximately 15 cm (6 inches) long. Draw lines diagonally across from the corners to find the centre. Start writing from the centre, turning the square 90° every time you reach the diagonal. Also, every time you turn, add a little water to the paint so that by the time you reach the outside of the square you are writing with very

diluted paint which is transparent and dries a little patchily. You will probably have to try out the idea two or three times before you make it work to your satisfaction.

Controlling the mixing like this will teach you how to achieve the best consistency, and show you how some pleasing effects may be worked by thinning paint or ink.

Poem by the Irish saint Colum Cille (Saint Columba), AD 521–97, founder of the monastery of Iona

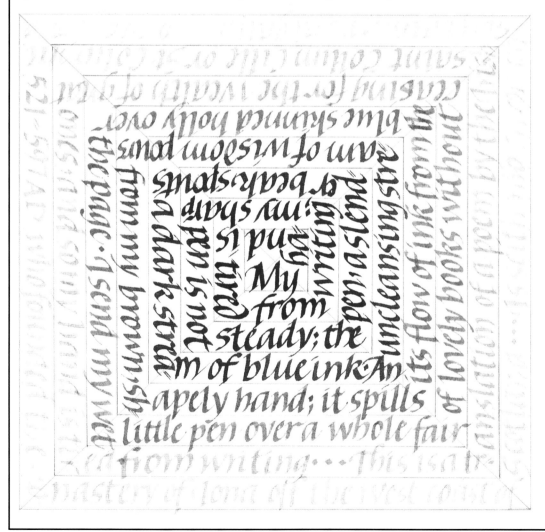

and absorbency, but may be used as a general-purpose designing paper and for less important work.

You will probably find that your local art store stocks a number of different papers, and, if you are lucky, they may stock some coloured papers known as cover and text papers. These come in a variety of colours and textures. The terms 'cover' and 'text' refer to the difference in thickness of the papers, which are often used for printing: cover papers are thicker than text. Although these papers are not expensive, they do cost more than ordinary cartridge papers. They are worth looking at and using, however, as the variety of colour and texture will add quality and an extra dimension to your work.

Of the cover papers available, two makes deserve special consideration: Fabriano 'Ingres' and Canson 'Mi-teintes'. These are very similar in quality and tooth (tooth is the quality in the surface which gives a certain amount of resistance or slight roughness), and the colours are good and lightfast.

As your confidence increases, you will want to use better-quality papers. Calligraphy and lettering are no different from other art forms, in that the better the quality of work, the better the quality of materials that are needed. This is not to say that using better materials is a guarantee of improved work; on the contrary, quality material often demands a higher level of skill to use it to advantage. Eventually, you will feel confident enough to search out the mould-made and handmade papers. These are not generally available in local art shops, but are stocked by specialist companies and stores.

If your work is to last more than a few years, make sure that you select acid-free papers. The cheaper papers are often made from wood pulp with a high acid content and are, in effect, self-destroying. These turn yellow and brittle with age. Better-quality papers are usually made from rag and are largely acid-free.

Papers from India and the Far East (especially Japan) are far more varied than European papers and are often made from a wider range of vegetable material. The surfaces vary considerably, and you must take care to select a surface which will take the ink and paints that you intend to use.

It is a good idea to buy a spare piece of paper for trials and experiments, or to use a piece of paper large enough to allow plenty of space around the final work, so that you can carry out trials. Using special papers is stimulating, but you must make sure that you can carry out a final rough that simulates the finished effect as closely as possible.

INKS AND PAINTS

Non-waterproof inks are best for most calligraphy. Black is the conventional ink colour, but there are other colours on the market, although often the inks are not lightfast or permanent. This is an important consideration when you are doing work for commission that needs to last for more than a few years. It is best to assume that your work is going to have a long life, and to use the better-quality inks to be on the safe side.

The finest black ink for calligraphy comes from China and Japan. These inks may be purchased in liquid form, or in the time-honoured form of a stick which has to be ground with water on an ink stone. The consistency of Chinese and Japanese inks may be controlled by the amount of grinding and water used. The liquid form is probably more convenient, although the consistency will probably need adjusting by the addition of water. Oriental ink is often perfumed and is pleasant to use: the effect is pleasing with a silky appearance to the surface when dry.

There are many different makes of ink on the market which are sold as calligraphy inks. These are, on the whole, quite good for most ordinary purposes such as designing, for work with a short-term life and for pieces which do not require the use of expensive materials.

It is quite possible – in fact quite normal – to mix paints to the consistency of ink for writing purposes. Either watercolours or designers' gouache would normally be used in this way, as they dilute well and flow through the pen (*not* fountain or cartridge pens). Mix a small amount of paint with a gradually increasing amount of water until, by trial and error, you find the optimum consistency. The paint must flow consistently, neither drying in the pen nor flowing freely but drying transparent and patchy.

3

PLANNING AND THE BASIC DESIGN PROCESS

In our western European culture we take the written and printed word for granted, and our signs, labels and lettering are often considered utilitarian. It is worth remembering that all lettering and printing has to be worked out and designed – that is, drawn or painted – by a designer, lettering artist or calligrapher.

We have two thousand years of alphabetic development at our disposal when designing work, and a host of printing styles from which to choose. These styles, or typefaces, are readily available from printers or transfer-lettering sheets. If we work as calligraphers, however, although we have many styles (or 'hands', as they are called) from which to select, we have to create each letterform afresh every time we write: each word or line is created instantly and cannot be altered if you change your mind. There is no going back once you have started.

The way in which you plan a piece of work depends on so many different factors that one could say there are no special rules. Perhaps 'do your own thing' could be the only rule! There are, however, some basic ways of working which experience has shown to be effective, and which apply to any kind of work.

Firstly, you need to know the main purpose of your work. Is it primarily a piece of communication, such as a notice, poster or an announcement? How is it going to do its job? Is it to be photocopied or printed? Perhaps you are creating a decorative work as an interpretation of chosen words. Is it a self-indulgent work as an experiment, or are you doing it for a special event or friend? Alternatively, you might be making a special presentation piece as a commission, working to a brief and to a tight timescale and budget. Once your intention is clear on these points, you can go ahead and work out your design.

SPACING

One of the most important aspects of any kind of lettering is spacing. Good spacing can improve any work; bad spacing will spoil even the best and most expert lettering. Although there are a number of guidance systems for spacing, the most reliable method is to learn to use your own eyes and judgement. Once good judgement is learned, the spacing systems become easy to use.

Good spacing is the even distribution of the letter stroke and the space that surrounds it. This sounds very straightforward, but it is rather like keeping good habits: it requires persistent effort to maintain and it is very easy to become lax with the passage of time. For this reason some exercises will help to train the eye.

The approach to spacing when doing some written lettering differs from that used with any kind of drawn or constructed lettering. In this section, we will look at how to develop a good spacing habit when using calligraphy to improve the appearance of your work.

Consistent speed and an even rhythm are very helpful in improving spacing when writing, and the more you practise, the better these should become, as long as variations are noticed and corrected each time. Look at the illustrations shown in this chapter and note the important points.

LAYOUT

Layout is really the visual arrangement and composition of the space around the overall design, and this includes decisions about the relative sizes and positioning of different elements in the design. The following projects and experiment will help you to learn by *doing*, or by trial and error, which is usually the best way.

(Below) The visual centre of a shape is *above* the geometric centre, so the margins need to take account of this. Most formal layouts use a centre line as a balancing point, but using a diagonal balance and contrasting the proportion of text area to margin can introduce tension and variety

(Opposite) 'He wishes for the cloths of Heaven' by W. B. Yeats. Peter Halliday (UK), 58 × 45 cm (22¾ × 17¾ inches). Flat gold, pencil and pencil crayon on Japanese paper.

In this moving poem I have tried to allude to the feelings expressed in an abstract form. By separating the gold above from the verse below I have created a sense of tension between the two main areas of the work, which compels the eye to move from the words to the area of gold and back again.

The paper surface was very soft and smooth, and I needed considerable sensitivity to achieve the right colour density. This 'risk' factor contributed to the way in which I approached the work by making me aware of the deep feelings underlying the words

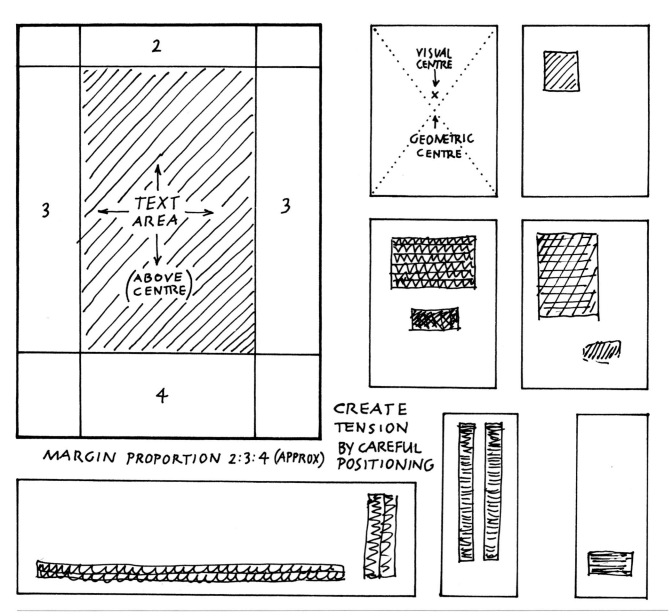

MARGIN PROPORTION 2:3:4 (APPROX)

CREATE TENSION BY CAREFUL POSITIONING

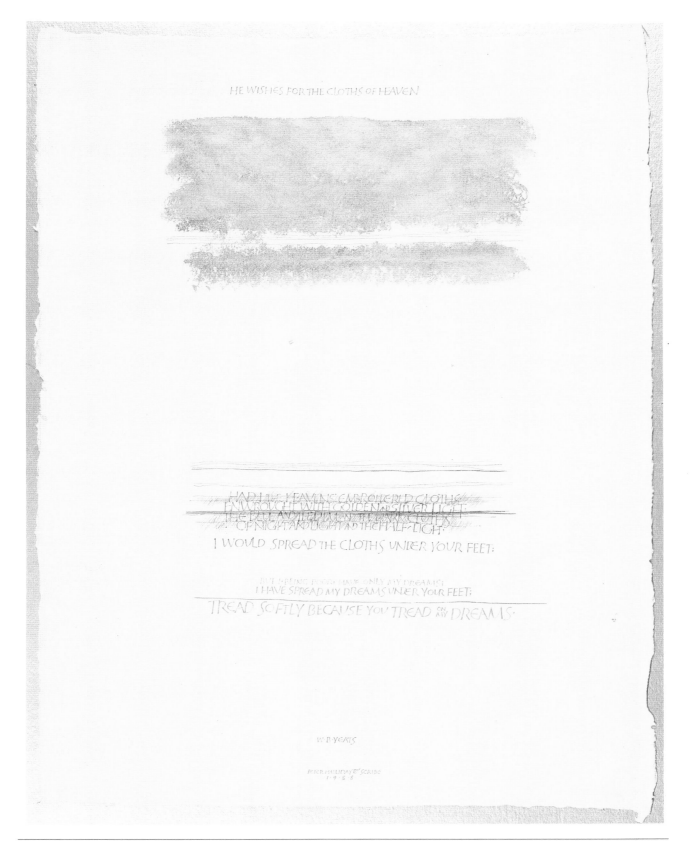

HE WISHES FOR THE CLOTHS OF HEAVEN

HAD I THE HEAVENS' EMBROIDERED CLOTHS
ENWROUGHT WITH GOLDEN AND SILVER LIGHT
THE BLUE AND THE DIM AND THE DARK CLOTHS
OF NIGHT AND LIGHT AND THE HALF-LIGHT
I WOULD SPREAD THE CLOTHS UNDER YOUR FEET:

BUT I, BEING POOR, HAVE ONLY MY DREAMS:
I HAVE SPREAD MY DREAMS UNDER YOUR FEET:
TREAD SOFTLY BECAUSE YOU TREAD ON MY DREAMS.

W B YEATS

PETER HALLIDAY SCRIBE
1 9 8 8

'Villu Tootsi Kalligraafia' by
Villu Toots Estonia. Poster,
86·5 × 58·5 cm (34 × 23 inches).
This poster shows a very effective
use of the three primary colours
on a black background

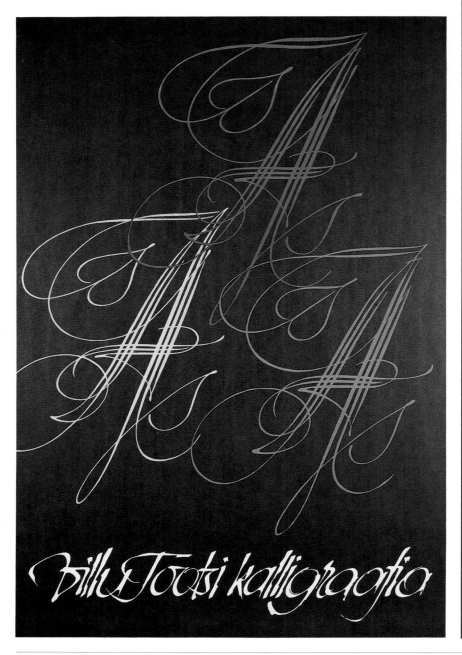

PROJECT *Designing a small poster*

When you design a poster, it is important that you organize the information into an order of priority. The information needs to be communicated in such a way that the poster attracts attention by giving quick, primary information (i.e., what is going to happen). Once attention is gained, the rest of the information may be arranged in descending order of importance, for example:

- what is it?
- when is it?
- where is it?
- how much does it cost?
- what other things are happening?
- miscellaneous information

Start by carrying out some thumbnail sketches such as those illustrated, and try to emphasize the information by different arrangements of words and contrasting sizes according to the relative importance of the messages.

Consider at this point which information should be in capitals and which in lowercase or small letters. Remember that capitals have

(Opposite, top)
Examples of thumbnail sketches trying out different layouts for a simple poster, with one idea *(opposite, left)* roughed out on a larger scale

(Opposite, right)
A final version of the rough design, ready for reproduction

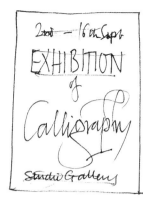
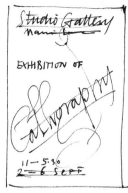

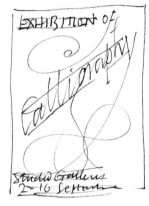
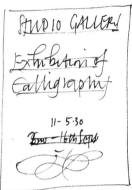

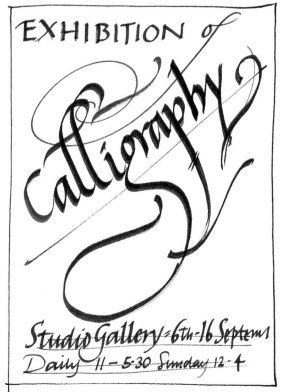
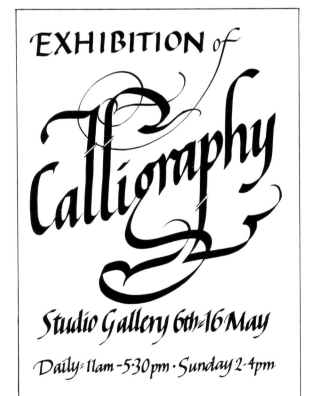

a tendency to carry more authority, but that lowercase letters sometimes make reading easier as well as being less formal. Contrasting the information by, for instance, using capitals for the main title and lowercase letters for the other parts of the message makes the design more effective by clearly identifying the information in each area of the design. As

they do not have ascenders or descenders, capitals will work well as even blocks of words. Written on a small scale, they may be used in the form of a decorative border.

When you have arrived at what seems to be a bold, original and clear arrangement, scribble out a larger version (you might even make it full size) and see if you can fit the

words into the spaces that you have planned. You will almost certainly have to try more than once, as you will probably select the wrong-sized pens. With experience, you will eventually manage with fewer false starts, but everyone needs to change and amend their designs as they develop their ideas, no matter how experienced they are.

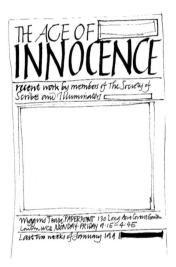

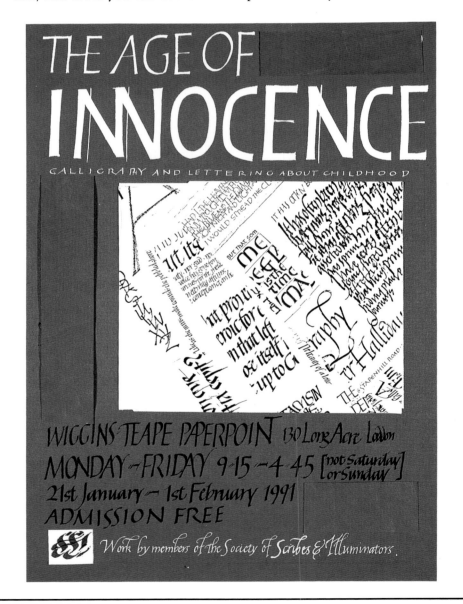

(Above and right)
Two stages in the design of a poster for an exhibition entitled 'The Age of Innocence'. The second stage *(right)* is the 'visual', a rough version which looks almost as if it were a finished work

So far, there has been no mention of measuring. It is better not to calculate and measure too soon, as this can lead to more effort later on when your calculations inevitably prove inadequate. Designing by trial and error and gradual adjustment *followed* by measurement is usually better.

Measure up your final design and carry out a trial version, taking into account all the alterations and variations that you have made. If it works, you can start on the final version. Beware of making last-minute changes, as these could throw your design into confusion and, in fact, you would be doing another version of the poster – another 'final' design.

Another, and often more convenient, way of designing is to start as described before but, instead of carrying through the complete design, work on each part of the information separately. When it looks right, cut out the line or word and paste it on to your outline design. When you have all the information pasted on, you can either measure up and do the final version, or place layout paper over your 'paste-up' and work over the design, following the design beneath. When you have a good version you can photocopy it, take it to the printers or make as many copies as you need by hand.

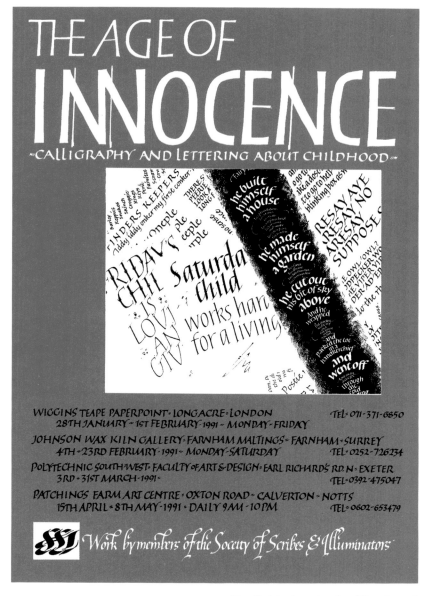

The finished poster for 'The Age of Innocence' by Peter Halliday (UK), 30 × 21 cm (11¾ × 8¼ inches). Two-colour lithoprint. I designed the white lettering as black on white, and then reversed it for printing. I made up the black-and-white panel insert by photocopying some of the works in the exhibition and making a collage

PROJECT *Designing a greetings card*

To design and make a greetings card, you may let your imagination range where it will. As a card is an informal and personal piece of work, your design need not be too formal either. Having said this, although it may seem the simplest thing to design something with only a few words, getting the idea to work is not as easy as it should eventually look.

Whereas a block of text may look quite good seen as a whole, the individual letters may not stand close scrutiny. To design a greeting with only two or three words means that they will not have the surrounding text to hide them. They must therefore be worked on in a more assiduous way – over and over again – until the words look 'right'. This design process means repeating the words twenty or thirty times, each time trying to improve the letters or to repeat a good idea again in the same way as you might have done earlier but by accident.

Always bear one thing in mind: the simplest ideas are often the best. There is always the temptation to make the work more elaborate, deluding yourself in the process that you are 'improving' what you are doing. It is better to make the simple idea work more simply, and, by doing so, to put your idea over more effectively.

You might start with some pencil ideas as thumbnail sketches, but the sooner you use pens the better. Italic fibre-tip pens are ideal for designing at this stage, and are also suitable if you are eventually going to print by photocopying or at the printers, as long as the pens are sharp and the ink dense.

EXPERIMENT

Take one word (a greeting or a name will do), and write it in as many different ways as you can for half an hour or so. At the end of this time you will have some good, some interesting and some awful ideas. Choose the two or three that you like best and try to repeat them, but improving on the original. This could be done by enhancing the quality of the letterforms, or by making the shape of the whole word look better.

Pay particular attention to the spacing. Look at the illustrations shown here and see how each of the progressive designs is a very slight change from the previous one. You will probably find that in getting one bit right, another part gets worse, but persevere. Use your layout pad so that you can overlay your work and use the previous words placed underneath as guides. This process takes time, but eventually you should arrive at a satisfactory version which you can re-write in an almost identical way as many times as you wish.

Notice that there are some good and some less good ideas among the alternatives shown here, which are about half the actual number of ideas that I had. Having chosen to take 'Congratulations' further, I needed to practise over and over so that my hand could 'remember' the movement sufficiently well to allow the final version (shown on the right) to be as good as possible

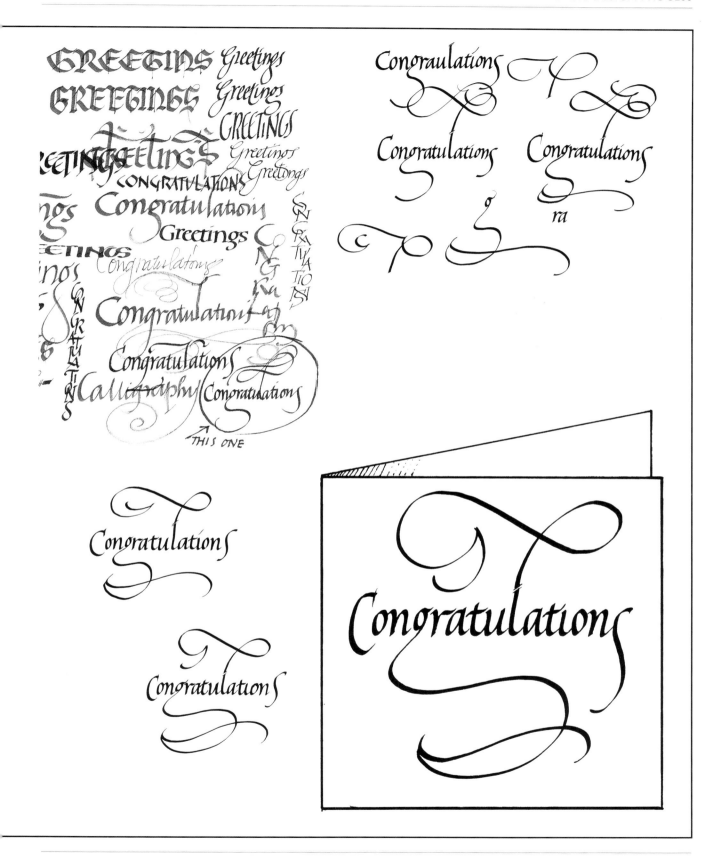

There are many different and interesting ways to arrange a greeting. You don't just have to write in a straight line: try arranging the words into a circle. You could use different-sized letters, or contrast the effect by using varying sizes of pen. The illustrations will give you some ideas to work from.

Many of the basic design procedures and problems are addressed in the working out of the small poster and greetings card, as described on pages 40–3 and 44–5. Undertaking and experimenting with these projects are very good ways of learning how to approach more complex work.

Some of the simpler ways of folding greetings cards

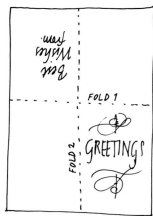

• *MESSAGE ON OTHER SIDE •* (*TWO PRINTINGS*)

• *MAKE SURE TO MAKE THE SIZE TO FIT A STANDARD ENVELOPE* •

Congratulations

FOLD 1

FOLD 2

Best Wishes from.

GREETINGS

• *IF PRINTING OR PHOTOCOPYING ONE PRINTING ONLY IS NEEDED WITH THE ABOVE FOLDING* •

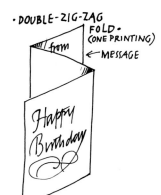

• *DOUBLE-ZIG-ZAG FOLD* • (*ONE PRINTING*)

← *MESSAGE*

from

Happy Birthday

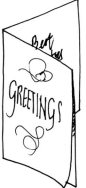

Best Wishes

GREETINGS

GREETINGS CHRISTMAS the

• *ORIGINAL IDEA* •

ROUGH SKETCH

(*Above and opposite*) Rough designs leading toward the production of a simple Christmas card for 1992

(Far right)
I had the final design printed on golden-yellow paper, and added some colour by hand. I developed each part of the design separately ('Christmas', the word 'Greetings' in a circle and the date), after which I photocopied them to various sizes. The components were then pasted down and the result printed. It is best to leave the final design on the large side so that the photocopy or print can be reduced in size when printing. This enables you to work on a larger scale, which is always easier

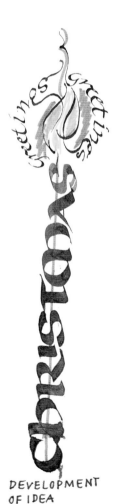

DEVELOPMENT
OF IDEA

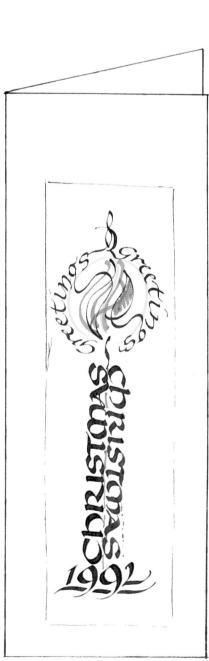

·ROUGH PASTE-UP
VISUALIZATION·

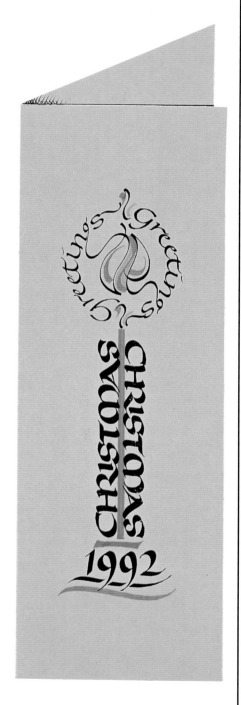

4

UNDERSTANDING COLOUR

There are many different ways of getting your designs to work well, and varying methods of using colour will add more subtle dimensions to your work. Some understanding of how to use colour effectively will really help.

COLOUR IS LIGHT

Colour is reflected light, and light reflected from a surface creates images on the retina of the eye. The images will have different physical effects according to the way in which various colours lie next to each other, and the effects will change if the intensity of light changes. Our initial reaction to colour, however, is often emotional, according to our particular likes or dislikes, but cultural reactions are also closely bound to our lives and history.

In Western cultures, a colour such as bright red is associated with war-like attitudes and anger, but is also used for its warm appearance and its association with heat. Black signifies death, mourning and sombre situations. White is used to show purity and

innocence, and blue can indicate calmness as well as sadness. Orange and yellow are sunny, warm colours, but used with browns clearly denote the season of autumn. Green tends to be cool and restful but also signifies youth and growth.

Used in combination, colours can reinforce their emotional connotations. The combination of blue and white, for example, creates a feeling of coolness much like our reaction when looking through a window on a winter's day. Black and red, when used together, become striking and can allude to a more sinister meaning. Purple still has the classical Roman association with wealth and nobility, but used together with black signifies mourning. The simple addition of a coloured initial letter on a page of black writing can lift the appearance and give life to an otherwise potentially uninteresting format.

Colour and its perception depend upon so many variables that it is difficult to predict how a viewer will react to, or perceive, our use of colour. The amount of light falling on different colours also

affects the intensity of the colour reflected. The use of words in calligraphy introduces the additional element of literary meaning, and the use of carefully considered colour will reinforce the message, sometimes in the subtlest of ways.

The addition of gold can enrich the ideas of wealth and nobility surrounding purple, and introduces the richness of light and warmth when used along with reds and oranges. As it has a shiny surface, however, gold introduces a complicating factor, which is covered in more detail on pages 64–7.

THE OBJECTIVE USE OF COLOUR

Understanding the theory of colour helps when deciding how to use colour in our work, but in the final analysis our own use of colour is as distinct as our personality. Variations are endless.

Tints and shades

When light is split into the visible spectrum, what we see are the colours of the rainbow: red, orange, yellow, green, blue, indigo and

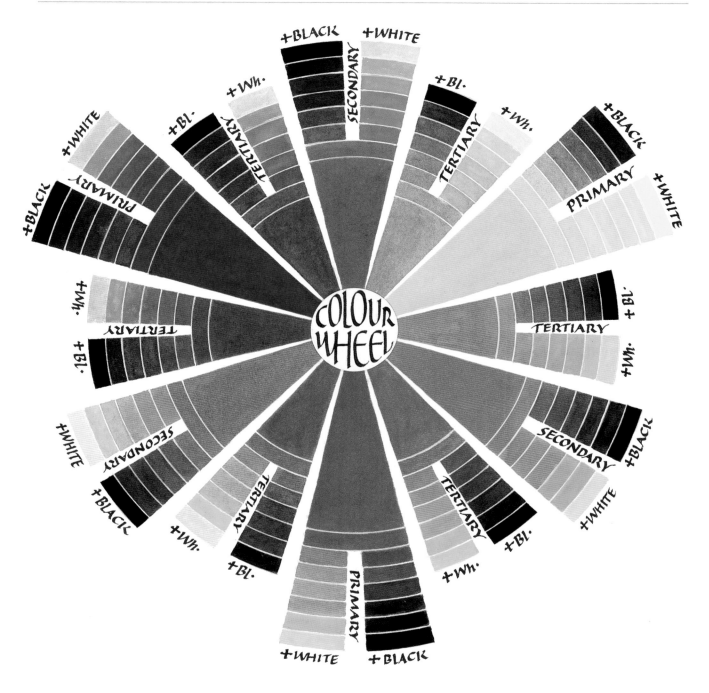

The colour wheel. Here, I have spaced out the three primary colours in the circle and divided them by the secondary and tertiary colours. Black and white do not appear (they are not colours), but I have added black and white to form tints and shades. Altogether there are 168 hues, tints and shades in this colour wheel

violet. These are called hues or pure colours. When mixing paints, the addition of white to any of the hues will make them lighter and will then be called tints. The addition of black or any dark, neutral colour will create a shade.

Tones and brightness

Tone refers to how light or dark a colour appears. Yellow is the colour with the lightest tone, and purple is the darkest. To visualize tone, imagine that the colours are being photographed in black and white or are on a black-and-white

television. The brightness of a colour depends on its intensity, and this varies according to how much the colour has been diluted when applied to a surface.

The colour wheel

A reliable way of visualizing how colours look is to work from a colour wheel. Primary colours are red, blue and yellow. They cannot be made by mixing other colours together. Secondary colours are made by mixing two primaries together: for example, blue and yellow mixed together make green. Tertiary colours are made by mixing a primary with a secondary: for example, green mixed with blue makes blue-green.

Colours are often referred to as warm or cool. If you look at the colour wheel on the previous page, you will see that red, orange and yellow are next to each other: these are warm colours, whereas blue and green are cool. Warm colours 'advance', which means that they sometimes seem to stand out against others. Cool colours, on the other hand, seem to recede. The way in which a colour appears to recede is related to the way we are conditioned to see distant landscape filtered by the faintly blue atmosphere, which tends to modify the actual, or local, colour of the objects in the landscape.

Local colour is the actual colour of the object: for example, a leaf *is* green and a daffodil *is* yellow, although these colours will be modified according to variables such as changes in the light or how far away from us they are.

(Opposite)
'Fog' by James Cunningham Gardner. Peter Halliday (UK), 27·5 × 19 cm (10¾ × 7½ inches). Watercolour on paper. Here, I engraved four layers of Perspex (Plexiglas) to create an interference pattern, and sandwiched the paper in-between. I used the landscape below as the basis for the cut-out hill shapes

(Below)
'Looking toward Stanage Edge from Sir William Hill, north Derbyshire'. Watercolour painting by Peter Halliday (UK), 19 × 27·5 cm (7½ × 10¾ inches)

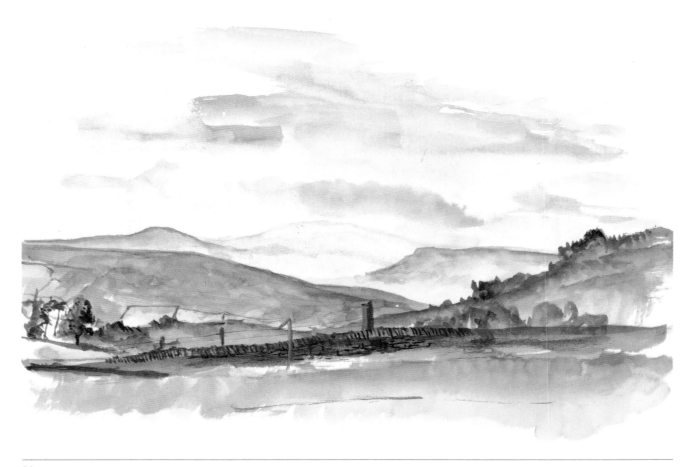

It comes with the dawn
goes with the sun·

For misty shroudof light
 … to bond a ….. prism

D ing soft nippu floating
with the wind·

Moves with deadly silence
like a cat ready to spring·

Covers – envelopes – with
mystifying magic

FOG by James Cunningham Gardner 1977–Peter Halliday Scribe August 1980

COLOUR EFFECT

No colour can be considered in isolation, because it and its neighbouring colours always look different according to the amount and intensity of each colour.

The most dramatic of colour effects is seen when using complementary colours alongside each other. Complementaries are those colours which lie opposite each other on the colour wheel. The complementary of blue is orange, the complementary of green is red, and so on. The effect of using complementaries can be very dramatic, with each colour making the other seem more intense.

The most extreme of the complementary effects is seen when red and green are put together. A spectrum red, when laid alongside a spectrum green in equal amounts,

Examples showing colour effect, contrast of extension and colour contrast. Although I repeated the same pattern for all the examples, the varying effects make the patterns appear different. I used the same primary and secondary colours throughout, and white and black to show the effects of contrast.

Complementary colours
As an experiment, place a piece of white paper alongside example G and stare hard at the design for about twenty seconds. Move your gaze to the white paper and you should see an after-image of the design, but in reverse. You should do this under a strong light, preferably sunlight. The same effect should work for examples H, I and A; the colour should appear to reverse, although it will be less intense.

Contrast
Look at examples B and C. Note how the sizes of the stripes seem to differ. They appear larger when they are white and smaller when they are dark.

Looking at example J, you should notice the change in the appearance of the red and yellow against white or black. The black has the effect of intensifying the colour (as it does also in examples B and C).

Examples D, E and F are not complementary, nor do they contrast, and they therefore have little effect on each other.

(*Note*: Some people do not have accurate colour vision, and, if this is the case, they will not see the effects in the way that they have been described here)

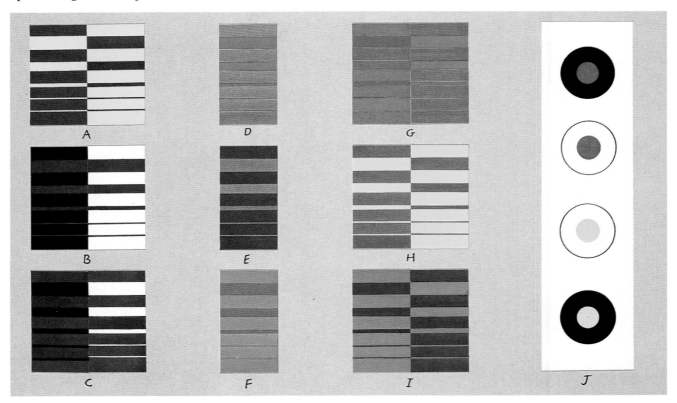

will seemingly have little effect; each colour will reflect the same amount of light. When the area of one is increased and the other reduced, however, the colour which has been reduced in area will seem to become brighter and almost appear to lift off the surface.

Another effect of using complementaries is to create an 'after' image, rather like the way in which we see a bright light for a few seconds after looking away. This 'contrast of extension', as it is called, can be seen around us all the time: red roses against their dark green leaves; pink blossom in springtime against new foliage; yellow and orange leaves against a blue autumn sky. Package designs on the supermarket shelves, where our attention is craved by the products, use colour effect without our realizing it. Complementaries

sometimes seem to create movement, or a kind of flashing, when the image is seen out of the corner of an eye, and a reflex action causes us to turn and look.

Contrast is a very important aspect of design when using colour. It can be described as the difference in tonal value of any two colours, each being lighter or darker than its neighbour. The most extreme contrast is black against white, and any strong contrast in a design will increase the clarity of the images.

COLOUR SCHEMES

As I have already mentioned, colour is a very personal thing. Most of us have our own ideas about colour schemes in our home decoration or in what we wear, but a little help in working out colour

These orange leaves against a blue sky and the Virginia creeper are good examples of complementary colours in nature

schemes will make things easier for calligraphy purposes. The following are three kinds of scheme.

Polychromatic (poly = many; chroma = colour)

This makes use of colours from all parts of the colour wheel. Medieval illuminated manuscripts have polychromatic colour schemes: the earlier ones use mostly primaries (gold acts as the yellow), with some secondaries.

(Above)
'Heraldic monsters' by Joan Pilsbury (UK), 20 × 81·5 cm (8 × 32 inches). Watercolour, raised and burnished gold and flat gold on vellum. This is a fine example of a polychromatic colour scheme. The heraldic subject lends itself to this traditional treatment, although the concept and design are wholly contemporary

Extract from 'Sir Gawayne and the Grene Knight'. Peter Halliday (UK), 43 × 36 cm (17 × 14 inches). Designers' gouache on Canson paper. The colour on this piece needed considerable trial and error to achieve the effect that I wanted. The style of calligraphy is one that I devised by turning the pen throughout each letter stroke. As the piece is in the original NW English dialect from Chaucer's time, the combination of this and the distorted letterforms makes it visually interesting but difficult to read

Monochromatic (mono = one)

This scheme uses only one colour with its tints and shades. (See the colour experiment based on newspaper textures on pages 59–61.)

Analogous (similar)

A scheme using colours from one section of the colour wheel, including their tints and shades.

Lettering and calligraphy create contrast and texture between the pattern of the letters. The degree of contrast and texture can vary a great deal depending on the size and weight of the letters, not to mention the colour of the background surface, and the effect is difficult to predict.

This colour variation is sometimes called induced colour, and can clearly be seen in woven fabric with a check pattern. When looked at closely, all the different-coloured threads will be seen separately, but at a distance the small areas of thread appear to merge and combine to create different colours. You will need to carry out full-sized colour trials because of this induced-colour effect before making up your mind about final designs. The results are often quite different to what you may expect.

I used the same blue pigment here, but the paper is different in every rectangle. Section A uses all blue papers. Section B uses shades of orange (the complementary of blue). Section C uses neutral, black and white. Section B has the greatest effect on the blue

· A · · B · · C ·

5

WRITING WITH DIFFERENT COLOURS AND PIGMENTS

With such a wide range of paints and pigments available today, the effects that we can achieve are many and varied. A basic use of a limited palette with variations is, however, more effective than the use of many colours.

Understanding the colour wheel and the theory of colour is useful, but the pigments available are mostly subtle variations of spectrum colours. Ideally, a pigment will always have the same colour value wherever it is used, but the way in which the manufacturer mixes it with ingredients (such as binding media) will alter the brilliance and colour purity.

ARTISTS' WATERCOLOURS

Apart from grinding and mixing your own raw pigments like the medieval illuminators, some of the purest forms of paints are artists' watercolours. These can be obtained in the form of small pans, but for our purposes the small tubes are more convenient, as they are in semi-liquid form and can be squeezed on to the palette in small quantities to be mixed with water to any consistency.

Some paints, such as French Ultramarine and Alizarin Crimson, will always be slightly transparent, and when used for writing will be difficult to use consistently. Other paints, such as Vermilion and Cerulean Blue, will be more opaque and easier to use. Artists' watercolours can be made more opaque by the addition of any opaque paint, such as Chinese White, but adding white always reduces the intensity of the colour and tends to make it look chalky. Adding white to Alizarin Crimson creates a pink, whereas adding Vermilion will create a rich and opaque red. A strong blue can be made by mixing a touch of Cerulean and a little Cobalt Blue with French Ultramarine.

Artists' watercolours are made from pigments of the finest quality and can be quite costly. As an alternative, manufacturers market watercolours which are very similar but cheaper, and except for the very finest work these will serve adequately.

DESIGNERS' COLOURS (GOUACHE)

These paints are more opaque than artists' watercolours, and also make it easier to apply flat and even washes of colour. The purity and brilliance of these paints are nearly as good as artists' watercolours, and it is easier to dilute the paint without losing too much opacity. These paints are generally thicker in consistency, but with careful mixing it is possible to maintain a mixture which flows well. You will need to mix the paint to a single-cream consistency in a suitable small mixing container, as described on page 35.

(Opposite) 'The Mountain' 'Ruhe fur mein einsam Herz' from Mahler's *Das Lied von der Erde*. Martin Wenham (UK), 45 × 32 cm (17¾ × 12½ inches). Watercolour on Bockingford 140 lb (300 gsm) paper.
The influences in this piece of painted lettering are varied. Martin Wenham had been studying the 'prismatic' and static effects of the early Cubists. Although Mahler was influenced, when near death, by the Austrian mountain scenery, Wenham based his ideas on views of the Pyrenees in Andorra. The letterforms were part of developing ideas of language games

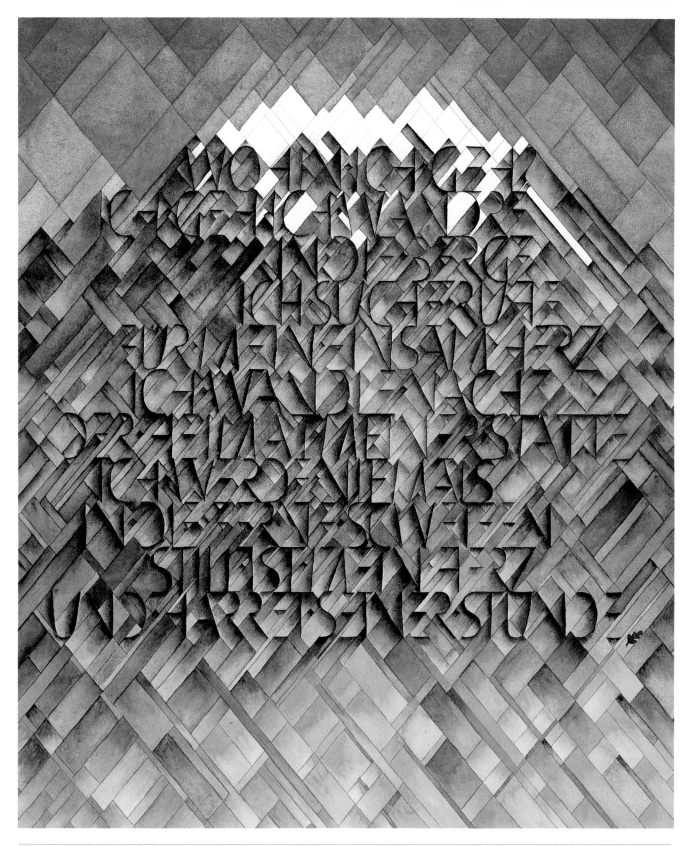

WHICH COLOURS TO USE

I have always found that using a limited range of colours is most effective. Starting with a small selection and then adding other colours when needed means that over-complicated colour schemes can be avoided. The following is a list of the colours that I use most often for writing.

Artists' watercolours

Reds

Vermilion (opaque). This may be used direct and does not need to be mixed with any other colours.
Alizarin Crimson (transparent). If mixed with Chinese White, this makes pink. If mixed with Vermilion it makes a rich red and the colour becomes more opaque.

Blues

Cerulean (opaque). This is greenish-blue in hue and may be used on its own, but is more satisfactory when mixed with a little Cobalt Blue and Chinese White.
Cobalt (opaque). I rarely use Cobalt on its own, but use it for mixing with other blues. With Cerulean it makes a greenish-blue, and with French Ultramarine it makes a more purple-blue.

Yellows

Aureolin (quite opaque). Used on its own for writing, Aureolin works well on white, but any other colour will show through. Aureolin is a light tone and therefore makes little contrast when used against white. Mixed with blues, it will give a good variety of greens.

Yellow Ochre (quite opaque). This gives the effect of gold when designing work.

White

Chinese White (quite opaque). When used for writing on a dark background, Chinese White will tend to be a little transparent and sometimes this can be attractive. To make it more opaque, some permanent white designers' colour may be added.

Greens

Oxide of Chromium (quite opaque). This is a pleasing green, which I find is best mixed with a little Aureolin to add brightness.

Browns

I sometimes use browns for writing. A brown can create a more subtle overall effect than black ink but, like any dark-toned colour, it can look indistinguishable from black in some circumstances. Sepia is a dark brown. Burnt Sienna, Raw Umber and Burnt Umber are lighter and warmer earth pigments. They are all quite opaque.

Purple

Winsor Violet (quite opaque). I do not use this colour often, but when mixed with Alizarin Crimson it will give a very deep purple, and with Chinese White will make an acceptable mauve.

Designers' colours

Reds

Spectrum Red and *Flame Red*. These are not as orange as Vermilion, but can be used for the same purposes.

Alizarin Crimson. This is more opaque than the artists' watercolour version, but is rather too deep to use on white paper as it will lose its colour and appear too much like black.

Cadmium colours

The cadmium yellows, oranges and reds are very good colours to use for writing purposes. They are strong, brilliant and opaque and may be mixed together to make a very wide range of hues. They range from Cadmium Red Deep through orange to Cadmium Yellow Light.

Yellow

Lemon Yellow. This is the lightest yellow.

Greens

Brilliant Green. This is quite a good, light green which is not too bright.
Viridian Lake. This is a strong, deep green. The use of blues and yellows to introduce more subtle shades is advisable.

Blues

The same blues as selected in the artists' watercolours list will work in the same way. French Ultramarine is more opaque as a designers' colour.

Browns

Use those mentioned earlier in the artists' watercolours list.

White

Permanent White. This is a very dense white which is very good for writing on dark surfaces. For fine work, a mixture of Chinese White and Permanent White gives a sharper finish.

COLOUR SYMBOLISM

The emotional or arbitrary use of colour – the use of any colours that you happen to like – is justified in calligraphy and, as we have seen, controlling colour effects can give your work considerable impact. Introducing symbolism to reinforce the literary message can add yet another facet of interest to your work.

Colour symbolism is less important in modern art than it was in pre-Renaissance times, but in modern society it is used to considerable effect in advertising and packaging – often without our knowing it. Red and green are the colours most commonly used to symbolize Christmas. Bright, primary colours (as on medieval manuscripts) against white are often used for detergents. Ecologically sound products use green, while 'pure' and wholesome food products are often packaged in wrappers using brown and yellow ochre, colours which symbolize the country-farmhouse 'image'.

In some ways, creating a piece of calligraphy is similar to packaging a product: first impressions are important, and they can begin to communicate your ideas before the words are read. The following list (continued on page 61) gives some symbolic meanings associated with colour.

Red

Fire, heat, danger, anger, bureaucracy (red tape), special day (red-letter day – from the rubricating of the Book of Common Prayer), virility, war, sex, prostitution, financial losses

EXPERIMENT 1

To realize how the size and weight of letterforms vary, just look at a page from a newspaper. From a distance, and through half-closed eyes, the page becomes a varied pattern of differing greys with the occasional headline clearly visible. The illustrations create a little light relief here and there.

If the page were to be printed in a colour, such as red, then the page would give the appearance of being printed in varying shades of red and pink. In other words, the size and weight will create tonal values.

Reducing the size of this newspaper shows the areas of print as varying shades of tone

As an experiment, try writing out blocks of text, rather like short columns of news, using various sizes and weights. Any colour will do, but write on white paper. Cut them out and paste them down as a kind of mosaic and stand back to appreciate the result. The same idea can be tried out by writing on black paper in white or in any light colour on dark paper, and the difference noted.

I wrote this example quite roughly to achieve the effect quickly

(Opposite) Work by a student, using the idea of cutting newspaper of various textures and colours as a starting point for a calligraphic layout

(Below) 'L'avenir dure longtemps' by Louis Althusser. The worked-up version of the illustration above it, 28 × 37·5 cm (11 × 14¾ inches). Pen-and-brush lettering in watercolour, gouache and acrylic, with cut paper: Canson and Indian wrapping-papers, birch bark and papyrus.

The newspaper idea suggested the development to the student, and he used materials to suggest the past (faded lettering, bark, papyrus) in contrast to the text

If the page were to be printed in a colour, say red, then the the page would give the appearance of being printed in varying shades of red.

be tried out by writing on black paper in white or in any light colour on dark paper and the difference noted

and weights. Any colour will do but write on white paper. Cut them out and

To realize how the size and weight of letter forms vary

just look at a page from a newspaper. From a distance, and through half closed eyes, the page becomes a varied pattern of differing greys, with the occasional headline clearly visible. The illustrations will create a little light relief here and there.

If the page were to be printed in a colour, say red, then the page would give the appearance of being printed in varying shades of red and

pink. In other words the size and weight will create tonal values. As an experiment try writing out blocks of

paste them down in a kind of mosaic and stand back to appreciate the result. The same idea can

To realize how the size and weight of letter forms vary just look a page from a newspaper. From a distance, and through half closed eyes, the page becomes a varied pattern of differing greys

text, rather like short columns of news, using various sizes

Blue
Coolness, sadness, boy baby, quality (blue ribbon), distance, brides ('something blue')

Yellow
Cowardice, warmth (with red and orange), danger (with black)

Gold (also yellow used as gold)
Affluence, generosity, nostalgia

Green
Spring, youth, jealousy, money (greenbacks), lack of experience, gardening (green fingers), envy, immaturity, ecology

Orange
Warmth (when used with red and yellow), Hallowe'en (with black), Dutch royal family (House of Orange), Irish Protestant

White
Purity, truce, cowardice, cover-up, heat, rage, the Presidency (of the USA), the Papacy

Black
Death and mourning, bad luck, good luck (black cat), despair, blasphemy

Grey (including silver)
Old age, penitence, smooth-talking, optimism (silver lining)

Pink
Optimism (rose-tinted spectacles), good condition, girl baby

Purple
Royalty, imperial, fine words (purple prose), mourning

Brown
The earth, autumn (with yellows and oranges)

(Below)
'This precious Earth', a letter from Chief Seattle to Isaac Stevens, Governor of Washington Territories (1855), used as a double opening of a book. David Wood (Australia), 21·4 × 29·5 cm (8½ × 11½ inches). Gouache, variegated gold and traditional gold on Arches hot-pressed paper and vellum.

David Wood explains: '. . . to me the Indians had a great respect for the earth but they weren't "stuffy religious" about it. Reading these beautiful words and ideas conveys their love and *freedom* for the earth to which they *belong*, so I tried to make the text "belong" to the large words'

EXPERIMENT 2

You can introduce a pleasing colour effect by gradually changing the mixing of the colour line by line. You will need to carry out two or three trials to ensure that you achieve the right effect.

Find five or six lines of text. Choose a fairly deep colour, such as a blue, mix it ready for writing (see page 35) and write out one line. Add a little white, enough to tint the colour slightly, bearing in mind that you will need to add a little more water to make it the correct consistency for writing. Write the next line and repeat the process for every line. You will see an almost imperceptible change line by line, but a noticeable change when comparing the first with the last.

It is of course possible to alter the colour in any way as you work, but adding any colour other than white calls for rather more experimentation, as the outcome is more difficult to predict.

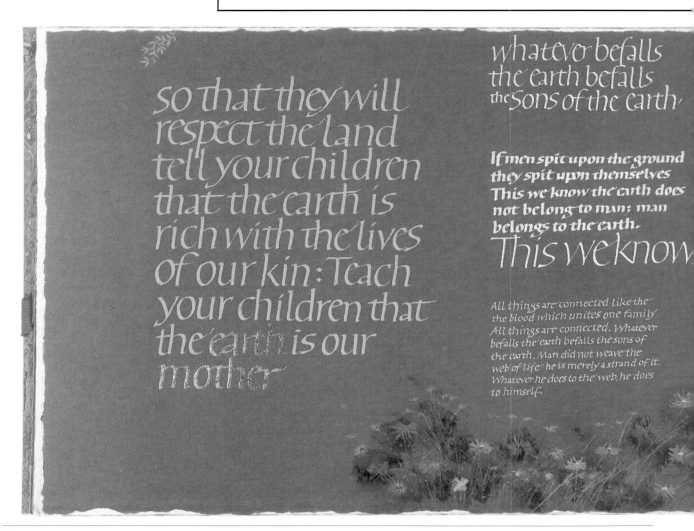

so that they will
respect the land
tell your children
that the earth is
rich with the lives
of our kin: Teach
your children that
the earth is our
mother

whatever befalls
the earth befalls
the sons of the earth

If men spit upon the ground
they spit upon themselves
This we know the earth does
not belong to man; man
belongs to the earth.
This we know

All things are connected like the
the blood which unites one family
All things are connected. Whatever
befalls the earth befalls the sons of
the earth. Man did not weave the
web of life he is merely a strand of it.
Whatever he does to the web, he does
to himself.

I wrote the first line in a mixture of French Ultramarine with a small amount of Cerulean Blue, and added a small amount of Chinese White for each line of writing

The glassy peartree
leaves and blooms,
they brush
The descending blue;
that blue is all in a rush
With richness.

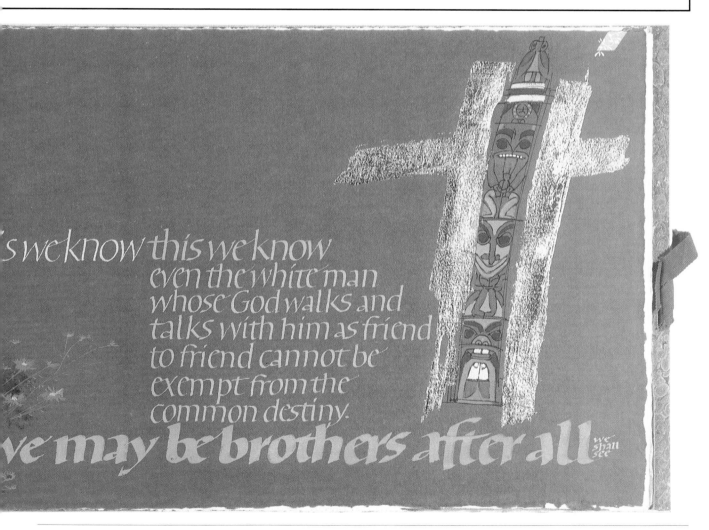

's we know this we know
even the white man
whose God walks and
talks with him as friend
to friend cannot be
exempt from the
common destiny.
ve may be brothers after all we shall see

6

USING GOLD AND OTHER METALLIC EFFECTS

Gold is the traditional material for enriching lettering and calligraphy, and is still, today, the most sumptuous way of decorating your work. There is no substitute for gold, although you can use coloured metallic powders and metallic paints which have interesting enriching effects.

GOLD LEAF

To decorate your work with gold leaf, or to illuminate it, all you need to do is to buy some gold leaf and find a substance which is sticky enough for the gold to stick to it, which then dries in a way that allows the gold to stay bright.

Several traditional and historical ways of applying gold have been researched since the first revival of calligraphy in the early years of the twentieth century. These have been used with great success, but the ingredients are not always readily available and we have to mix them up ourselves to be certain that the mixture is right. There are modern media available, which I have used successfully. Of these, PVA (polyvinyl acetate) medium

is the easiest to use and can be bought at your local art store.

PVA medium

PVA medium is made for mixing with paints, and dries virtually transparent, and hard but flexible. To stick gold leaf to it you will need to dilute it 50:50 with water (always wash your brush immediately after using PVA as it dries hard and will not wash out easily) and add a little red paint. Adding red paint makes the PVA visible and also enriches the colour of the gold.

The most convenient type of gold leaf for use with PVA is transfer gold leaf, where the gold is attached to paper. You can buy this from suppliers of signpainting and decorating materials, or from specialist calligraphy suppliers.

Once you have prepared the PVA mixture, paint it on to the surface and allow it to dry thoroughly for a few minutes. Although dry, it will be slightly tacky, and you can then press the gold leaf on to the surface and rub it down. The gold should stick to the painted area only, and any ragged edges may be lightly

brushed away with a clean, soft brush reserved for the purpose. Do not touch it with your fingers.

Burnishing

You can burnish the gold almost straight away to give it some shine, although it is best to leave it for half an hour or longer – even overnight. Burnishing is done with a special burnisher made of agate, or similar material (obtainable from specialist suppliers).

You can achieve a similar, but less shiny, effect by laying a piece of smooth shiny paper (glasine or so-called crystal parchment is best) over the area and, without moving the paper, carefully rubbing with your thumbnail or a round, hard, smooth object. Make sure that you do the gilding on a firm surface such as a thick piece of glass or a plastic worktop so that you are less likely to dent the paper.

Creating texture

Depending on the subject matter, I try to use PVA in such a way as to let the texture of the surface show through; this allows the gold to 'glisten' rather than to be just flat

and even. By making the mixture more dilute, the textures can be made to show more clearly, but the more the mixture is diluted the less sticky it becomes and the gold will not adhere quite so readily.

If the gold leaf does not stick well first time, apply another layer of gold, but this time, before rubbing down the gold, breathe on the surface to make it slightly more sticky, immediately lay on the gold leaf and repeat the earlier procedure. This time it should work, but you can repeat the process as many times as are necessary. As a last resort, you can lay a very dilute layer of PVA over the work and repeat the whole process.

Decorative effects

There are a number of ways of creating attractive decorative effects when using gold. I make patterns by pressing a texture on to the gold leaf, once it is dry and fairly hard, using a hard object such as the hollow point of an empty ball-point pen. By placing some thin paper (such as glasine or thin tracing paper) over the gold, it is possible to draw patterns through it using a fine ball-point pen or a hard pencil (a 2H will do) which has a slightly rounded point. This has the effect of denting the surface. You will need to make sure that you can position the decoration accurately.

It is even possible to mix fine sand or fine sawdust with the PVA to give a textural surface, although this makes application of the gold more difficult as you will need to keep pressing the gold into the small nooks and crannies. It may be more convenient to use a textured paper instead.

EXPERIMENT 1

Take a piece of textured paper and paint the PVA mixture into three 2·5 cm (1 inch) squares drawn about 1·5 cm ($\frac{1}{2}$ inch) apart. Gild the squares, as described opposite, and then decorate them with design ideas that you have previously worked out, by impressing with a point.

Stages showing gilding

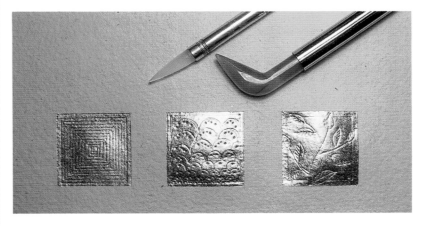

EXPERIMENT 2

Draw out a letter (see page 84) within a square measuring about 2·5 cm (1 inch). Make sure that there is a small space between the letter and the square shape. Leaving the letter clear, paint the background with the PVA mixture. Apply the gold leaf and brush away the surplus gold to reveal the letter – ungilded. Burnish the gold before you continue. You can now paint in the letter in whatever colour you like.

Gold is always put on before any paint is applied, as it is likely to stick to the painted areas. Any gold remaining on the surrounding areas may be gently removed with a soft eraser, or dabbed lightly with Blu-Tack that has been kneaded to a point. Be very careful to avoid touching the gold areas, as you may inadvertently remove your gilding.

Stages showing the gilding of the letter 'A'

OTHER METALLIC EFFECTS

As I have already mentioned, there are other traditional ways of using gold, as well as gold- and metallic-coloured paints, which will bring enriching effects to your work. A very important aspect of using gold and metallic powders is that they should be regarded, for design purposes, in the same way that you would consider and use colour. You will need to bear in mind when designing work that light reflects differently according to the amount and direction of light falling on the work.

Whether you are using gold or other metallic powders, you will need to pay careful attention to mixing. The first thing to notice is the way in which the tiny metal particles will tend to sink to the bottom of your palette. To counteract this, you must mix frequently by stirring beneath the surface to keep the mixture in suspension. The separation will continue in the brush and in the pen, so you must be sensitive to the consistency of the mixture as you are using it. Trial and error will tell you how well you are succeeding. A patchy and uneven finish means too much water; a lumpy finish and frequent drying out of the brush or pen means too little water.

Powder gold

This is sometimes called shell gold, as it used to be prepared on a half-mussel shell. This is the most expensive kind of gold to apply, as it is a mixture of pure gold powder ready mixed with a glue or gum, and sold in the form of a small block. It is used by mixing with water in the same way as watercolour. It can be applied by painting with a brush, or used for writing with a pen.

Shell gold is most appropriate when used for small areas of decoration, such as small spots, and where gold is applied on top of pigment already laid. Although it is possible to burnish powder gold, it will never reach the bright finish of gold leaf.

Metallic powders

Metallic powders are manufactured in a variety of 'colours', such as Copper, Sequin, Pale Gold and Ducat Gold, and are simply mixed with water and applied as if they were paints. Burnishing is unlikely to enhance the effect significantly.

Metallic paints

These are used in the same way as the powders, but are manufactured in liquid or semi-liquid form. Remember that there is no real substitute for genuine gold. Metallic paints and powders will create effects unique to themselves, and, if you try to compromise by imitating gold with a substitute, the integrity of your work will suffer.

7

FINDING INSPIRATION

Although calligraphy is usually about words, texts and their meaning, it is quite possible – and sometimes desirable – to use illustration and source material from the visual stimuli around us. Often it is a matter of pausing to consider the possibilities of ordinary and familiar things, such as a hitherto unremarkable plant, stone or pattern.

'The arms of Sir Gerald Woods Wollaston' by Peter Halliday (UK), 42 × 31 cm (16½ × 12 inches). Raised and burnished gold, flat gold and watercolour on calfskin vellum.

This is a very complex coat of arms combining the arms of the Wollaston family and the arms of Garter King of Arms. It includes the major honours, the wand of office and the chain of 'S's with the badge hanging from it (they would be worn by Garter King of Arms at ceremonies such as the state opening of Parliament). The badges of the four countries of the United Kingdom are featured. Two representations of the family arms are shown, each with a different motto used by two branches of the family.

All the materials used for this panel are the traditional ones associated with the production of illuminated manuscripts during the middle ages, and are entirely appropriate for such a piece of work

'Gulf' by Denis Brown (Eire), 113 × 56 cm (44½ × 22 inches). Mixed media on two calfskins, with charcoal wood. The 'Gulf' here is represented by a split, within which is a charred piece of wood. The golds and coppers represent the flames of war and destruction seen in the Gulf war against Saddam Hussein. Gold also represents the richness of Kuwait. Both sides of the divide are connected by thin copper wire to symbolize the attempts to find solutions during any war. The word gulf is used in various ways, as a definition as well as on its own, and is seen by Brown as relevant to the theme

It is worth spending time looking at objects like this, and taking advantage of their textural or design effects. Having said this, the words – the subject matter of the text – must be paramount and the relevance of the illustrative material maintained.

Careful observation and drawing lie at the root of the matter, and even if you are someone who has always been a little afraid of drawing because of what others might think or say, DON'T BE AFRAID. Draw for yourself, draw for a particular purpose and don't think that you have to be somewhere special to begin.

'Alpha and Omega' (Kurdish elegy) by Denis Brown (Eire). Two calfskins over a canvas stretcher with bronze powder, gouache, gold leaf, copper leaf, copper wire and barbed wire.

The inspiration for 'Alpha and Omega' focuses on the aftermath of the Gulf war. Brown has used quotations from a translation of 'The Gododdin', an ancient poem lamenting the annihilation of a whole army in Gododdin in northern Britain. The ancient is in juxtaposition with the modern and they become relevant to each other in the plight of the Kurds being pushed northward in their own land

Start at home and try drawing ordinary, familiar things around the home or in the garden. Simple household objects such as kitchen utensils, electric plugs, shoes and so on are all worth tackling. Try drawing a simple leaf exactly to size, almost as if you were making a copy from a photograph. As well as developing your drawing skill, all this will help you to improve your observation and to develop your powers of synthesis, which is the way of translating what you see into what you draw or paint.

It is a good idea to keep a sketchbook handy, which can you use whenever you find an opportunity. Remember: don't make adverse comparisons with highly skilled artists and trained designers, but *do* look at and admire the good work of acknowledged experts.

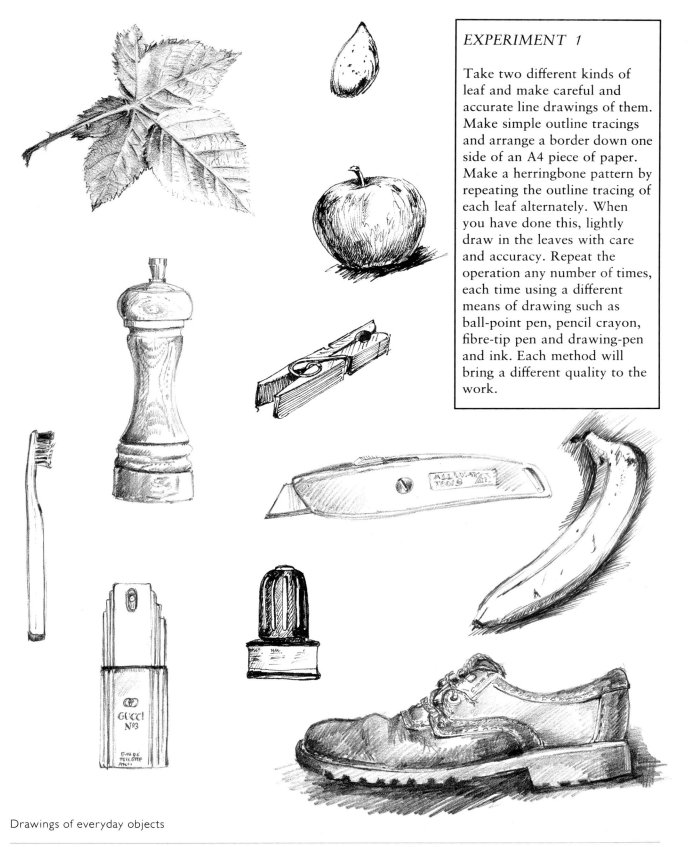

EXPERIMENT 1

Take two different kinds of leaf and make careful and accurate line drawings of them. Make simple outline tracings and arrange a border down one side of an A4 piece of paper. Make a herringbone pattern by repeating the outline tracing of each leaf alternately. When you have done this, lightly draw in the leaves with care and accuracy. Repeat the operation any number of times, each time using a different means of drawing such as ball-point pen, pencil crayon, fibre-tip pen and drawing-pen and ink. Each method will bring a different quality to the work.

Drawings of everyday objects

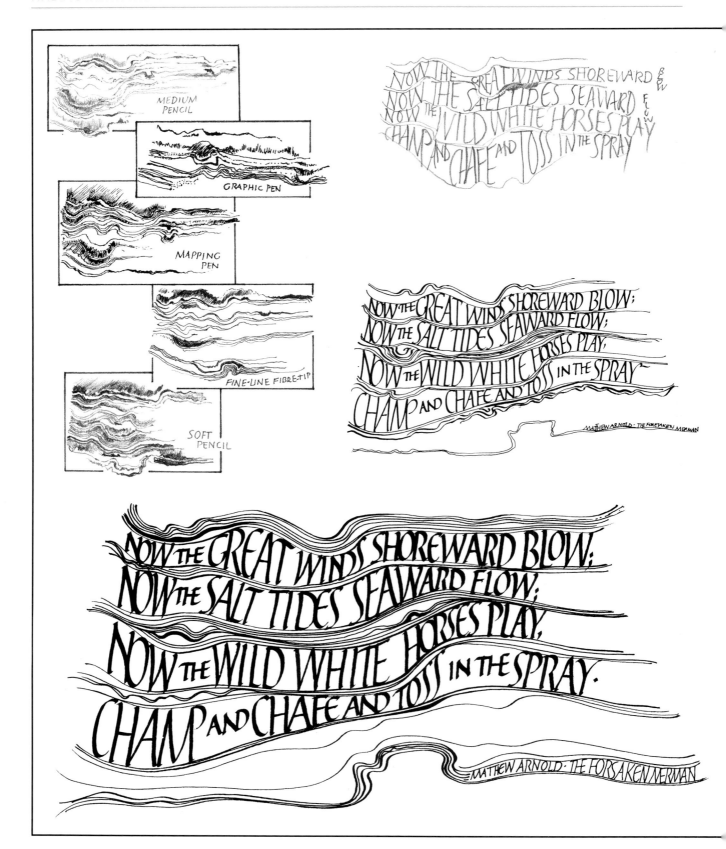

MEDIUM PENCIL

GRAPHIC PEN

MAPPING PEN

FINE-LINE FIBRE-TIP

SOFT PENCIL

NOW THE GREAT WINDS SHOREWARD BLOW
NOW THE SALT TIDES SEAWARD FLOW
NOW THE WILD WHITE HORSES PLAY
CHAMP AND CHAFE AND TOSS IN THE SPRAY

NOW THE GREAT WINDS SHOREWARD BLOW;
NOW THE SALT TIDES SEAWARD FLOW;
NOW THE WILD WHITE HORSES PLAY,
CHAMP AND CHAFE AND TOSS IN THE SPRAY
MATTHEW ARNOLD · THE FORSAKEN MERMAN

NOW THE GREAT WINDS SHOREWARD BLOW;
NOW THE SALT TIDES SEAWARD FLOW;
NOW THE WILD WHITE HORSES PLAY,
CHAMP AND CHAFE AND TOSS IN THE SPRAY.
MATHEW ARNOLD · THE FORSAKEN MERMAN

EXPERIMENT 2

Find a stone or pebble with a strong linear pattern on the surface, or a decorative piece of agate or onyx such as the one used for this example, and copy the pattern with a fine drawing implement such as a fine-line fibre-tip pen, mapping pen or sharpened pencil.

If you draw several versions and concentrate on specific but different areas, progressively filling a page of your sketchpad, you will have a page of visual information or analytical drawing. Try lightly re-drawing the most successful drawing on a slightly larger scale. Then choose some appropriate words and use the lines to guide your writing. Varying the size according to the pattern will create an interesting, but controlled, pattern of calligraphy.

As variations on this idea, you could try writing with the same pen that you used for drawing, or try drawing with a calligraphy pen. Allowing some of the original drawing to be repeated here and there will also introduce an alternative pattern element.

(Opposite, top) Drawings of a section of onyx stone in five different media. The pattern suggested movement, and I selected a quotation about the sea, from 'The Forsaken Merman' by Matthew Arnold, to accompany it

(Opposite) I carried out the final version of the pattern and poem on fine handmade paper

PROJECT *Combining a simple illustration with a quotation*

> 'Leaves
> Fallen on a rock
> Beneath the water'
>
> *Joso*

If you wish to use illustration alongside a quotation, it is usually a good idea to look for the essence of the words' meaning, or the underlying idea, rather than being too literal. This is because calligraphy and fine lettering have an abstract quality which sometimes makes an over-realistic illustration or literal interpretation unnecessarily trite or over-complicated.

It is always more difficult to select words that you are going to write out than you first realize. I have chosen a Japanese *haiku* verse, which alludes to a feeling of experience rather than a description of an event. A simplified, or formalized, drawing of leaves could be used as a starting point here. These could be placed at the top with the poem beneath, although a number of trial sketches need to be carried out first (see overleaf).

I have chosen a cream or off-white paper which has a slightly rough tooth for the final version. To begin with, however, I need to work on the layout to develop the idea. This is done on layout paper in one colour at first until an acceptable layout is worked out. At this point I will introduce colour, and will try a sepia brown for the writing and shades of brown for the leaves.

A photograph of some leaves underwater, which form the starting point for the *haiku*

Developments of rough ideas for the *haiku*

LEAVES
Fallen
on
a
rock

LEAVES
Fallen on
a
Rock

BENEATH THE WATER

BENEATH THE WATER

If the trial seems promising, I will work on the design to improve the balance of the layout and to raise the quality of the writing. Familiarity with the quotation and the order of the layout will mean that it is possible to concentrate or focus on the action of doing the work, without worrying too much about copying the words or remembering where they should go on the paper. The ideal method is to *rehearse* sufficiently, but without doing too much practice, so that enough spontaneity is saved for the actual piece of work.

When I have reached the right point, I will carry out a careful trial on a spare piece of identical paper. The *feel* of the paper being used for the final version will be different from the practice paper, and sensitivity to this change is an important factor in producing a relaxed final version.

When I am confident that I am ready to start the final version, I will begin with the writing, as this part is the most likely to go wrong and the most difficult to correct, and then work on the illustration.

(Below and opposite)
The final idea and the final rough working, showing trials and notes for fine adjustments

LEAVES
fallen
on
a
rock

BENEATH
THE WATER

LEAVES
Fallen
on
a
rock

BENEATH
THE WATER

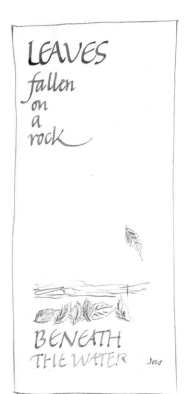

LEAVES
fallen
on
a
rock

BENEATH
THE WATER

(Right)
Haiku: the finished piece.
Watercolour on G. F. Smith text
paper, written with a metal dip pen

A pencil drawing of rose leaves

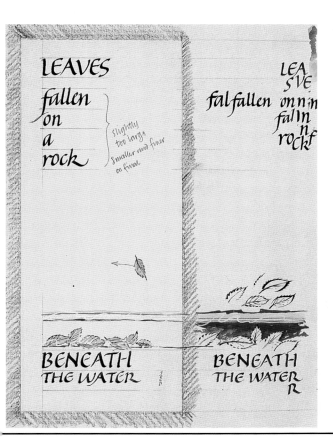

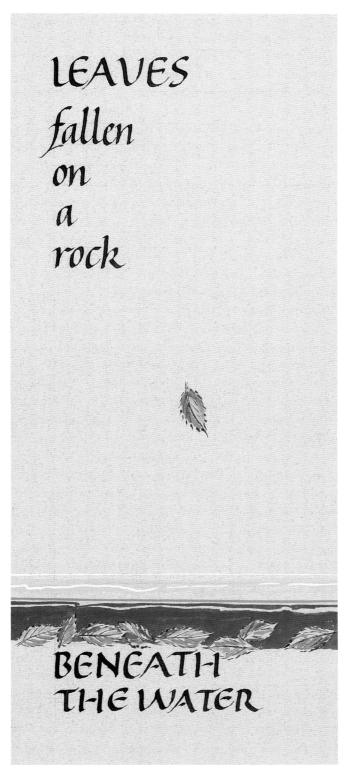

INSPIRATION FROM LITERATURE

A love of words and language is an asset when developing an interest in calligraphy. Although calligraphy can be purely practical, the spontaneous and direct nature of its delivery means that an expressive and creative dimension can introduce wider applications. This use of calligraphy and lettering in

(Right) 'Mauern mit Gras' by Johannes Thurnau. Hans-Joachim Burgurt (Germany), 33 × 24 cm (11¾ × 9½ inches). Ink, pens and brush on handmade paper, in a printed book

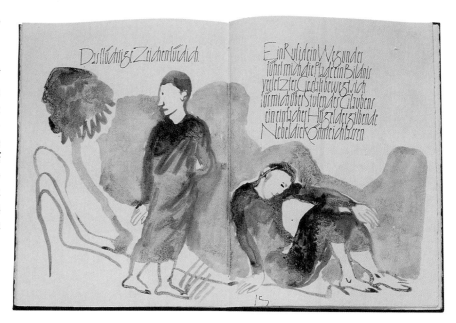

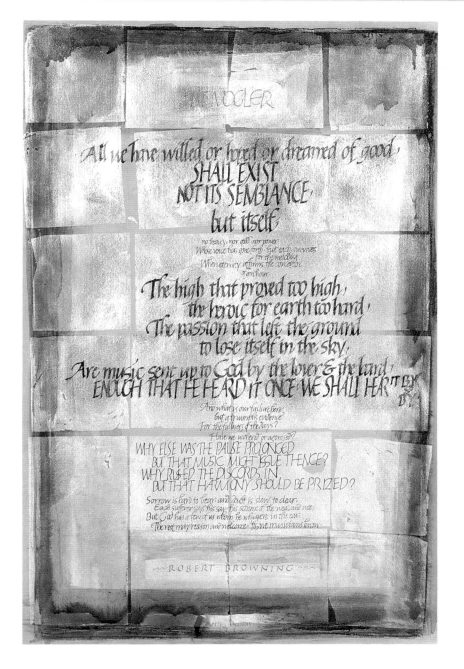

ABT VOGLER

All we have willed or hoped or dreamed of good,
SHALL EXIST
NOT ITS SEMBLANCE,
but itself;

no beauty, nor good, nor power
Whose voice has gone forth, but each survives
for the melodist
When eternity affirms the conception
of an hour...

The high that proved too high,
the heroic for earth too hard,
The passion that left the ground
to lose itself in the sky,
Are music sent up to God by the lover & the bard,
ENOUGH THAT HE HEARD IT ONCE WE SHALL HEAR IT BY
AND BY

And what is our failure here
but a triumph's evidence
For the fullness of the days?

Have we withered or agonised?
WHY ELSE WAS THE PAUSE PROLONGED
BUT THAT MUSIC MIGHT ISSUE THENCE?
WHY RUSHED THE DISCORDS IN
BUT THAT HARMONY SHOULD BE PRIZED?

Sorrow is hard to bear and doubt is slow to clear,
Each sufferer says his say, his scheme of the weal and woe
But God has a few of us whom he whispers in the ear,
The rest may reason and welcome, 'tis we musicians know.

ROBERT BROWNING

(Opposite)
'Metamorphosis' by Franz Kafka. Christine Hartmann (Germany). Christine Hartmann paints and writes experimental works and is always looking for new shapes of our time by bringing together the colour of painting and the line of calligraphy. She tries to make art by script and looks for the magic power of letters – of the rhythm of writing

From 'Abt Vogler' by Robert Browning. Peter Halliday (UK), 60 × 40 cm (23½ × 15¾ inches). Chinese ink and watercolour on silver leaf. I laid the silver leaf on the paper after preparing it with PVA medium. I then sealed the silver with a dilute mixture of PVA and carried out the writing over the top. I washed this, flooded on the crimson watercolour and sponged it off

more of a fine-art context has been a developing aspect during the last thirty years.

Interpretation of literature is a very personal thing, and attempts to achieve this through calligraphy need to be taken in small steps. It should always be remembered that the words are the most important means of conveying the ideas, a fact that is sometimes forgotten in the desire to make the work interesting or unusual.

Some of the finest calligraphy produced this century relies on the strength of penmanship alone, and has no illustration. There is a risk that too much reliance upon pretentious creative ideas will have a tendency to diminish the importance of the words. Simple use of colour, variation in the size of writing and an emphasis on the quality of calligraphy come before too much literal use of illustration and looseness of letterforms. Do not confuse freedom with undisciplined use of letterforms.

There is a clear link between the ability to draw and the ability to use sound letters and create good design. Coming to terms with our limitations is one of the most important aspects of being able to make good use of our abilities.

The direct way in which calligraphy has to be delivered can be compared with the way in which musicians work. They need to practise and rehearse, no matter how good or illustrious they are, to become proficient so that they can perform without having to worry about the technicalities of their art. Performance is the whole object: practice for its own sake is pointless. The same is true of calligraphy. There is little point in practising endlessly without

(Left)
Inspired by the song 'Peace in the Valley'. David Howells (UK), 40 × 50 cm (15¾ × 19¾ inches). Watercolour, pens and paper. David Howells first heard this song on the radio, and used the idea to produce this work, which he describes as a painting

(Below)
'Blow, blow, thou winter wind' by William Shakespeare. Peter Halliday (UK), 20 × 34 cm (8 × 13½ inches). Pencil, pencil crayon, watercolour, gold and silver on ancient Nepalese paper. The very direct nature of the pencil on this rough and open-textured paper demanded considerable sensitivity when working. As the paper was translucent, I placed a piece of more opaque paper underneath

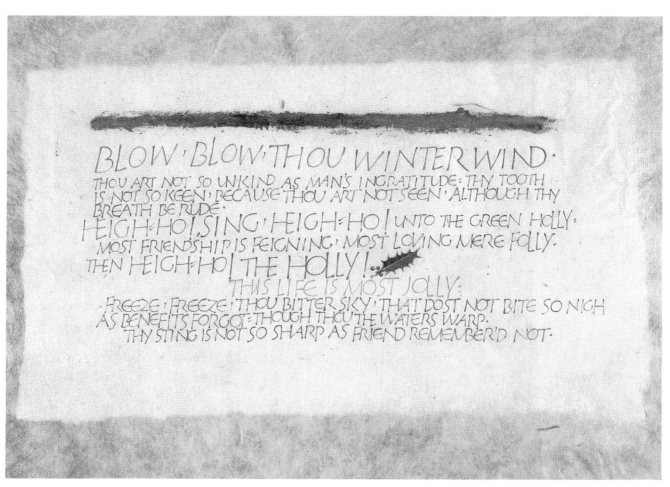

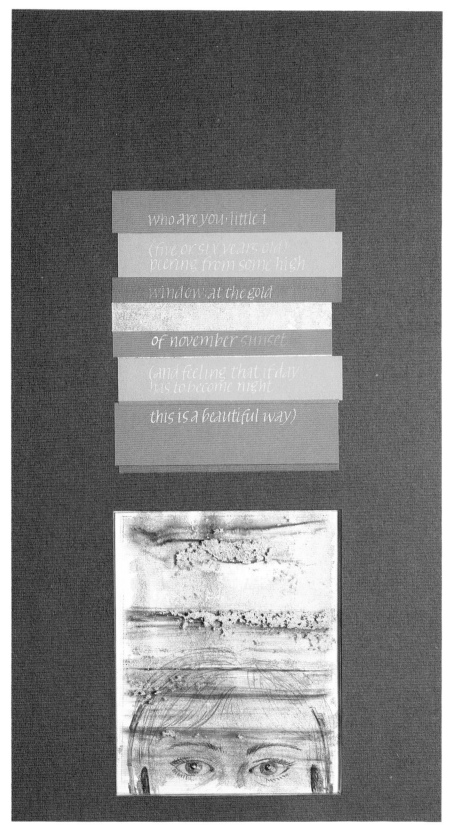

Poem 52 from *73 Poems* by E. E. Cummings. Peter Halliday (UK), 34 × 27·5 cm (13½ × 10¾ inches). Watercolour, gold, cut paper and Perspex (Plexiglas) on Fabriano and Japanese papers. The idea of the small person looking through the window at sunset is an emotive one. I have drawn my youngest daughter and put Perspex with gold over the top to create a sense of double image (© 1963 Marion M. Cummings)

creating a finished product, but careful and meaningful 'rehearsal' with an end product in mind is not only desirable but necessary.

I have found that looking for subject matter can be a time-consuming process. Nevertheless, it can also be a very rewarding one, as I will need to read and reject much fine writing before I decide on the poem or other passage of writing to be used. The selection of subject matter is a very personal decision, and your own likes and dislikes will determine what you eventually choose.

The way in which I usually make a choice is to look, almost at random, for a poem or piece of literature. I have certain preferences, and particularly like the English metaphysical poets of the seventeenth century as well as twentieth-century poets such as E. E. Cummings, Jon Silkin and Tom Gunn, although I am always broadening my reading. Often the length and shape of the work will be a factor in deciding on a piece, but particular imagery is always important in the final decision, even though the imagery may not be directly illustrated.

Having chosen the work to be done (unless it has been chosen by a client), the first thing to do is either to select a pen and write out

AARONS BEARD · WINTER ACONITE · COMMON AGRIMONY
SWEET ALYSSUM · MARSH ANDROMEDA · WOOD ANEMONE · ANGELICA
YELLOW ARCHANGEL · MOUNTAIN AVENS · BALM · INDIAN BALSAM
YELLOW BARTSIA · WILD BASIL · FEN BEDSTRAW · BEE ORCHID · BELLFLOWER
BIRS EYE PRIMROSE · BIRDSFOOT TREFOIL · BROAD LEAVED DOCK
BLACK BRYONY · BUGLE · BUR CHERVIL · BURNET ROSE · BUTTERFLY
ORCHID · BLADDER CAMPION · CARLINE THISTLE · CATS TAIL · CHERVIL
MOUSE EARED CHICKWEED · CREEPING CINQUEFOIL · CLOUDBERRY
CLUSTERED BELLFLOWER · COLUMBINE · COMFREY · FORGET ME NOT
HEMP NETTLE · FUMITORY · MEADOW RUE · CORN BUTTERCUP · CORYDALIS
BLOODY CRANESBILL · CREEPING BELLFLOWER · CUCKOO FLOWER · CUDWEED
WILD DAFFODIL · DARK MULLEIN · DOGS MERCURY · DOTTED LOOSESTRIFE
DOWNY HEMP NETTLE · DRAGONS TEETH · DYERS GREENWOOD · EARTHNUT
EGLANTINE · ENCHANTERS NIGHTSHADE · FEN ORCHID · FIELD COWWHEAT
FICLEAVED GOOSEFOOT · FIGWORT · FRINGED WATERLILY · FRITILLARY
FIELD GENTIAN · GERMANDER SPEEDWELL · GOLDEN SAMPHIRE · GORSE
GUELDER ROSE · HEARTSEASE · WINTER HELIOTROPE · HERB BENNET
HOARY ALISON · HONEYSUCKLE · RED HORNED POPPY · MARSH
HORSETAIL · JACK BY THE HEDGE · BROWN KNAPWEED · KNOTTED CLOVER
LADYS BEDSTRAW · LAMBS LETTUCE · LARKSPUR · ROCK SEA LAVENDER
LESSER TWAYBLADE · LODDON LILY · IVY LEAVED LUCERNE · LUNGWORT
FIELD MADDER · MAIDEN PINK · MARGUERITE · MARJORAM
MARSHWORT · MIGNONETTE · MONKSHOOD · MYROBALAN · MYRTLE
OX EYE DAISY · PALE BUTTERWORT · PERSICARIA · PANSY · PASQUE FLOWER
PELLITORY OF THE WALL · PENNYROYAL · GREATER PERIWINKLE
PHEASANTS EYE · PIMPERNEL · PLOUGHMANS SPIKENARD
POLICEMANS HELMET · PRICKLY LETTUCE · PROCUMBENT PEARLWORT
RAGGED ROBIN · RAMSONS · RED VEINED DANDELION · ROCKROSE
ROSE OF SHARON · RUE LEAVED SAXIFRAGE · MEADOW SAFFRON
SAND CATCHFLY · SANDWORT · SANICLE · ALPINE SAUSSURA · SAVORY
SCENTED MAYWEED · SEASIDE CENTAURY · ANNUAL SEABLITE
SHEEPS BIT SCABIOUS · SELF HEAL · SHEPHERDS CRESS · SILVERWEED
SNEEZEWORT · SPRING SNOWFLAKE · SOLOMONS SEAL · SORREL
SPEAR LEAVED ORACHE · LESSER SPEARMINT · SPRING BEAUTY
SPIGNEL · BROAD LEAVED SPURGE · AUTUMN SQUILL · STARWORT
SQUINANCYWORT · STAR OF BETHLEHEM · SPURGE LAUREL · SUNDEW

WHAT GREATER DELIGHT IS THERE
THAN TO BEHOLD THE EARTH
APPARELLED WITH FLOWERS
AS AN EMBROIDERED ROBE

ENGLISH STONECROP · COMMON STORKSBILL · SWINECRESS
SUN SPURGE · SWEET CICELY · TALL BROOMRAPE · THORN APPLE · THALE
TANSY · TEASEL · THREE NERVED SANDWORT · THRIFT · THYME
TOADFLAX · TOOTHED MEDICK · TORMENTIL · TOUCH ME NOT
TOWER MUSTARD · TOWNHALL CLOCK · TRAVELLERS JOY · TURNIP
TREACLE MUSTARD · TUTSAN · TWINFLOWER · GRASS VETCHLING
VALERIAN · VERVAIN · PALE WOOD VIOLET · VIPERS BUGLOSS · WALLFLOWER
WARTCRESS · FINE LEAVED DROPWORT · WAVY BITTERCRESS
WHITE BRYONY · WATER PLANTAIN · WELTED THISTLE · WALL PEPPER
WOODY NIGHTSHADE · DOWNY WOUNDWORT · WORMWOOD
CREEPING YELLOWGRASS · WOAD · YELLOWWORT · ZIG ZAG CLOVER

SWEETEST LOVE I do not goe for wearinesse of thee

(This page)
Stages showing the working out and production of the poem 'Sweetest Love' by John Donne (the third stage and final version are shown overleaf). The first stage (above) shows my original thumbnail-sketch ideas; the second stage (right) shows the text written out on to the panels before I added the colour

(Opposite)
Extract from *Gerard's Herbal*, first published at the end of the sixteenth century. Margaret Daubney (UK), 29 × 26 cm ($11\frac{1}{2}$ × $10\frac{1}{4}$ inches). Watercolour on Arches aquarelle paper using steel nibs. The colour was changed after each flower name had been written

SWEETEST LOVE,
I DO NOT GOE,
FOR WEARINESSE OF THEE,
Nor in hope the world can show
A fitter Love for mee;
But since that I
Must dye at last, 'tis best,
To use my selfe in jest
Thus by fain'd deaths to dye;

YESTERNIGHT THE SUNNE
WENT HENCE,
AND YET
IS HERE TO DAY,
He hath no desire nor sense,
Nor halfe so short a way;
Then feare not mee,
But beleeve that I SHALL MAKE
SPEEDIER JOURNEYES, since I take
MORE WINGS & SPURRES THEN HEE;

O how feeble is mans power,
That if good fortune fall,
Cannot adde another houre,
Nor a lost houre recall !
But come bad chance,
And wee joyne to'it our strength,
And wee teach it art and length,
It self or us to advance.

When thou sigh'st, thou sigh'st not winde
But sigh'st my soule away,
When thou weepst, unkindly kinde
My lifes blood doth decay.
It cannot bee
That thou lov'st mee, as thou sayst
If in thine my life thou waste,
Thou art the best of mee.

Let not thy divining heart
Forethinke me any ill,
Destiny may take thy part,
And may thy feares fulfill,
But thinke that wee
Are but turn'd aside to sleepe;
THEY WHO ONE ANOTHER KEEP
ALIVE, NE'R PARTED BEE.

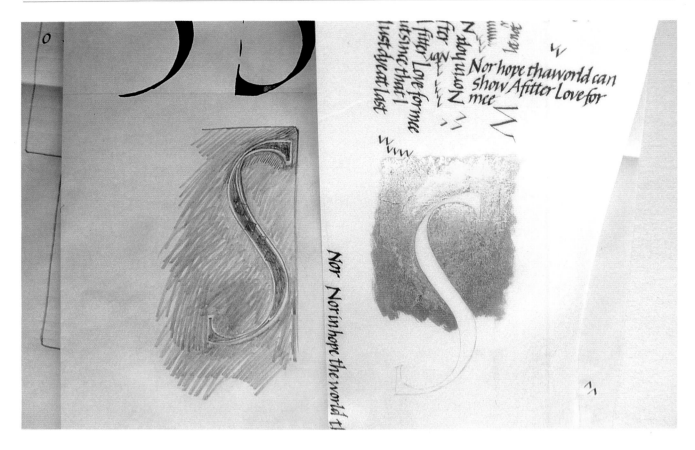

the piece, or to carry out some preliminary thumbnail sketches. In both cases, the reason for this is to begin visualizing the work. Sometimes I will do some background research into the subject of the work, and try to learn a little more about the writer and the motivation for the piece. Much of this preliminary work will begin, almost subconsciously, to form some interpretative ideas, which I will then jot down and begin to try out by re-writing or re-drawing the thumbnail sketches.

At this stage I will need to begin crystalizing my ideas by making a more disciplined rendering of the work. I will also start to introduce any illustrative material, as well as considering aspects such as colour, materials and the surface on which to work.

Unlike the more structured manner of designing described in Chapter 3, my method of proceeding is not entirely predictable. Sometimes my ideas develop quite quickly and sequentially, but at other times I may try out and then abandon several ideas until I am satisfied.

Although designing may seem to be an erratic process with much work abandoned, I find that the process of working through all the ideas is never actually wasted. Designing and creating work is rather like going on a journey: you may lose your way but you are always moving toward the destination, no matter how many diversions there are. Once I have set out on the 'journey' I don't turn back, and eventually find my way to a destination.

(Above) This third stage shows the working out of the initial 'S'

(Opposite)
'Sweetest Love' by John Donne: the final version. Peter Halliday (UK), 34 × 23·5 cm (13$\frac{1}{2}$ × 9$\frac{1}{4}$ inches), excluding frame and mount. Chinese ink, watercolour and gold on calfskin vellum; Japanese paper on the background.

There are six small panels each covered with vellum, and I attached these to a backing of Japanese paper mounted on to a gilded base. I fixed the panels at varying levels so that they cast differing shadows.
I scraped away parts of the text, as the poem deals with departing and the piece was commissioned as a retirement present. The picture framer raised the piece on to a black plinth to give it space and depth

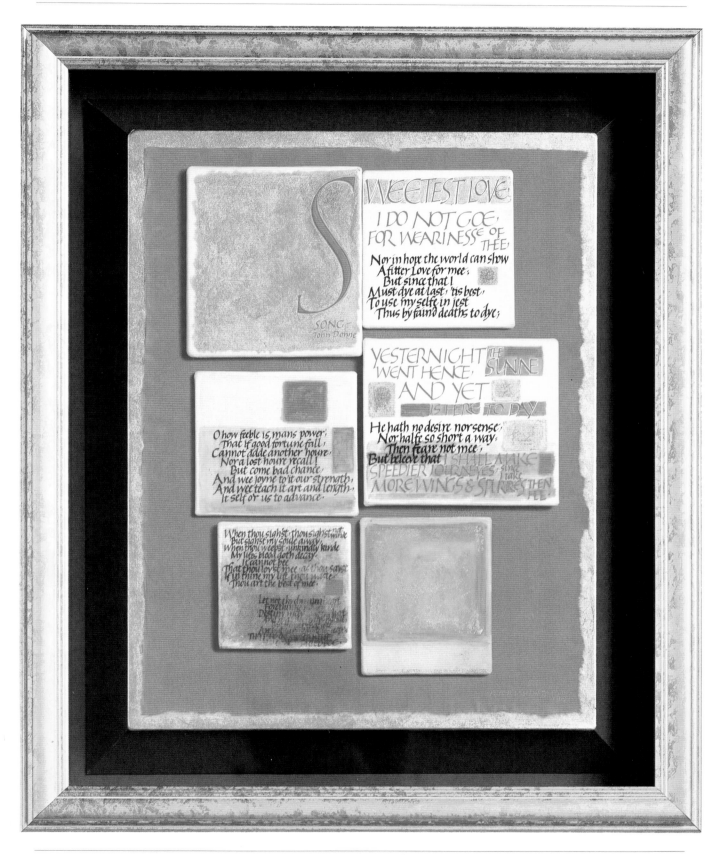

8

DRAWING LETTERS

There will be times when the job that you are planning will need some of the letters to be drawn rather than written. This could be for a title or a logo design, for instance.

Depending on the kind of job you are going to do, the drawing of letters can have certain advantages over a calligraphic approach. These advantages include:

- re-drawing and correcting
- tracing over previous drawings
- drawing out letters separately and pasting in

There is a risk, however, that in drawing letters separately, the uniformity of your overall design could suffer. Drawing skill and consistency of letterforms are very important.

CAPITAL LETTERS

The satisfying, basic proportions of the Roman capital alphabet form the basis of all our printed and most familiar alphabets. In simple terms, this alphabet is based on the idea that the letters can be contained within a series of squares and half-squares, but with slight variations and anomalies. The variations take care of optical effects and make the letters *look* right.

An alphabet will always adapt to a particular language, and our English one contains K, Y and Z, which were not normally used in the Latin Roman version, and J, U and W, which have been developed for use with north European languages.

SKELETON PROPORTIONS

The proportions of letters depend on the area that they occupy, not the actual width of the letter. The 'square' letters are:

OQCGD (basically round)
HUNTAVZ (slightly
narrower than square)

The 'narrow' letters (grouped together in letters of similar shape) are:

EFL, PRB, S, KXY

The 'exceptions' are:

I and J, M and W

Once the skeleton letters are drawn, freehand, the thickness is added, in most cases, on the *inside* of the lines and then serifs are added. To add the thickness to the *outside* of the skeleton letter would change the proportion. A good way of adding the thickness is to use a double pencil held at an angle as if it were a calligraphic pen. This will produce the thin and thick lines in a similar way to the brushes or reed pens which were probably used by the Romans to lay out their inscriptions. The thick stroke needs to be approximately one-eighth of its height, and the thin strokes will be about half the width of the thick (see opposite).

(Opposite and overleaf)
Roman capitals

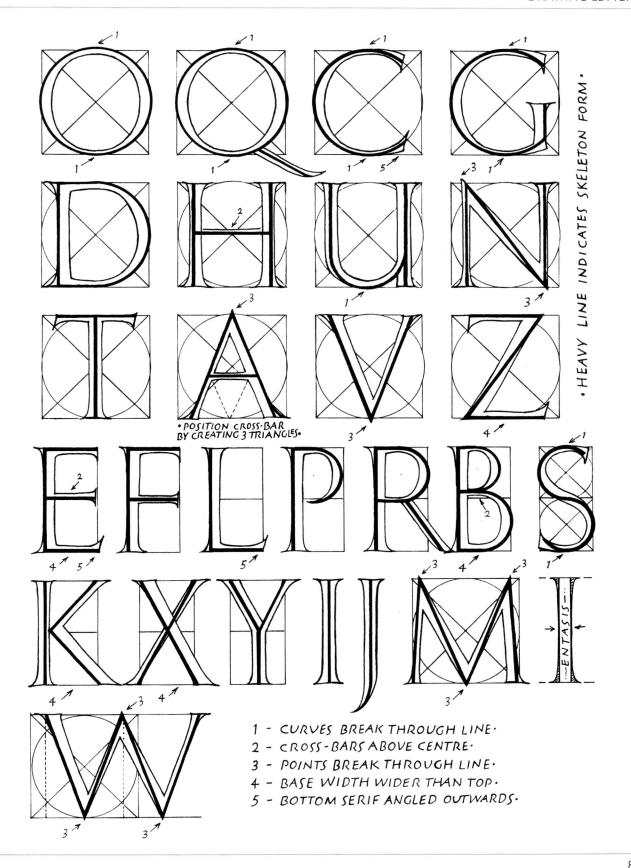

• HEAVY LINE INDICATES SKELETON FORM •

• POSITION CROSS-BAR BY CREATING 3 TRIANGLES •

— ENTASIS —

1 - CURVES BREAK THROUGH LINE·
2 - CROSS-BARS ABOVE CENTRE·
3 - POINTS BREAK THROUGH LINE·
4 - BASE WIDTH WIDER THAN TOP·
5 - BOTTOM SERIF ANGLED OUTWARDS·

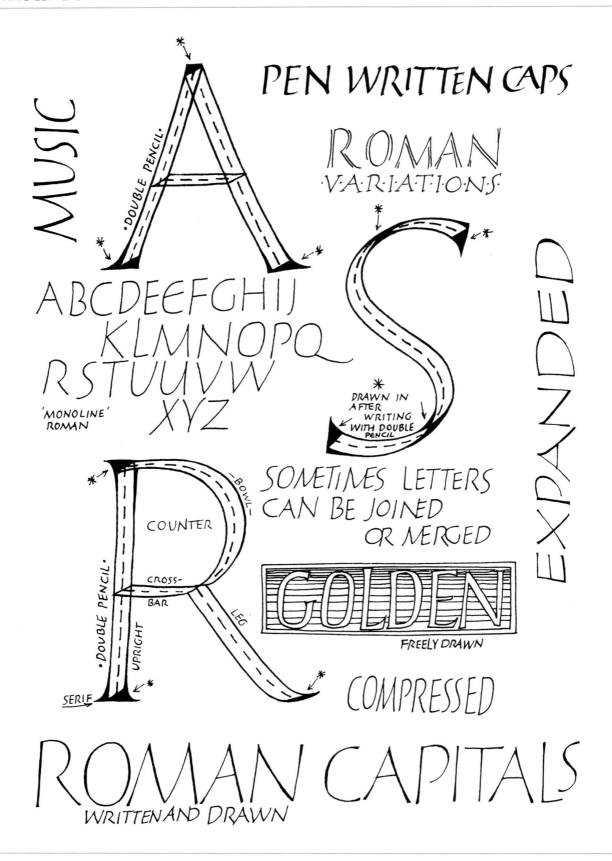

MUSIC

PEN WRITTEN CAPS

ROMAN
·V·A·R·I·A·T·I·O·N·S

·DOUBLE PENCIL·

A

S

EXPANDED

ABCDEEFGHIJ
KLMNOPQ
RSTUUVW
XYZ

'MONOLINE'
ROMAN

DRAWN IN
AFTER
WRITING
WITH DOUBLE
PENCIL

R

—BOWL—

COUNTER

CROSS-
BAR

·DOUBLE PENCIL·

UPRIGHT

LEG

SERIF

SOMETIMES LETTERS
CAN BE JOINED
OR MERGED

GOLDEN

FREELY DRAWN

COMPRESSED

ROMAN CAPITALS
WRITTEN AND DRAWN

ENTASIS

This is an architectural term, which describes how columns are made fatter in the middle to counteract the optical illusion of the column looking too narrow. In a row of columns, the spaces in between appear narrower at the centre. Entasis must be introduced into drawn letters, especially Roman letters, to counteract this illusion (see the illustration on page 85).

Note: All hand-drawn Roman alphabets will vary, and looking at other designers' versions will help to establish your preferences. Look at typefaces such as Hermann Zapf's 'Palatino' or Eric Gill's 'Perpetua': they are good examples of contemporary Roman forms derived from sound perception of historical examples. Study as many different historical versions as you can find and *make up your own mind* about your version.

PROJECT Drawing out the word 'Romans'

Rule two guidelines about 5 cm (2 inches) apart. With a 2B or No. 2 pencil, draw the skeleton outlines of the letters, touching the guidelines. Do not consider spacing at this stage. Add the thicknesses and the serifs. Draw lightly and smoothly, using an eraser to correct your drawing and to keep your work clean.

Unlike the spacing method for written calligraphy, you can experiment with and adjust your spacing before finally drawing out your letters (see below).

Take some tracing paper or thin layout paper and draw two guidelines, the same distance apart as before. Carefully (but not too carefully) trace each letter and shade it in roughly. Try to space the letters evenly, as

shown. Even spacing should give an even texture to the inside area of the letters (the counters), and the same area between each letter. Looking at your drawn letters from behind the tracing will help you to see the word as a pattern of shapes. To adjust the spacing, either keep re-drawing until you get it right, or cut between the letters, move them and tape them into position.

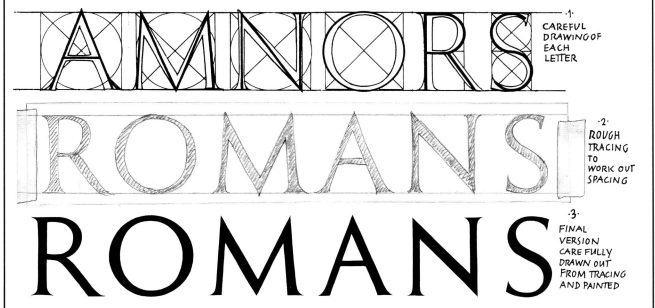

·1· CAREFUL DRAWING OF EACH LETTER

·2· ROUGH TRACING TO WORK OUT SPACING

·3· FINAL VERSION CAREFULLY DRAWN OUT FROM TRACING AND PAINTED

Once you have spaced the letters, measure the spaces and make a very careful tracing with a harder pencil, ensuring that the spacing is now correct according to your measurements. Do not shade in the letters this time.

To transfer your final tracing to your chosen paper or surface, first turn the tracing over and, with the softer pencil, draw precisely over the outline of the letters. Turn the tracing over again, place it down in position on the selected surface and fix it with masking tape or Blu-Tack.

Make the final tracing by drawing with the harder pencil. Do not press too hard: draw just with sufficient pressure to allow the tracing to be visible. You should now have an exact outline of your original. Paint or fill in the letters in any way you like. Shading with pencil to give the impression of a V-cut, incised letter is a good option if you don't wish to paint or otherwise colour the letters.

This method of tracing out your lettering may be used for all drawn letterforms.

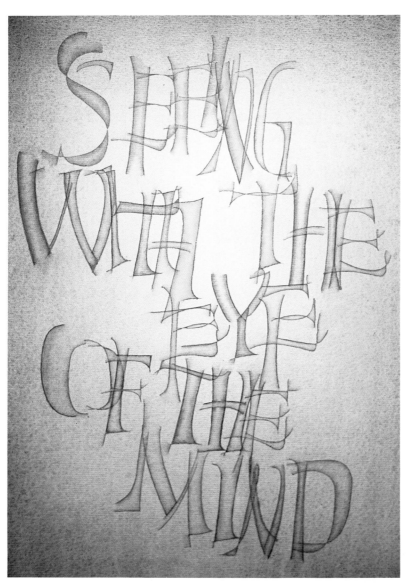

'In the country of the blind' by Martin Wenham (UK), 42·5 × 30 cm (16¾ × 11¾ inches). Watercolour on Bockingford 140 lb (300 gsm) paper.

Martin Wenham drew each word separately in pencil with his eyes shut. He then assembled the words, pasted them up and photocopied them. He traced them on to paper using a black oil-paint transfer technique developed by Paul Klee, and painted using graded washes of colours made from French Ultramarine, Cadmium Red, Winsor Green, Winsor Violet and Oxide of Chromium. Drawing letters in this way makes possible the use of gesture, as in Chinese and Japanese calligraphy, by guiding the drawing with remembered gestures

(Right)
'Hallelujah' from 'Rejoice in the Lamb' by Christopher Smart (1722–71). Martin Wenham (UK), 81 × 39 cm (32 × 15½ inches). Letters cut into yew wood. The letters were drawn first to avoid the five large knots and then cut with chisels, with direct incisions

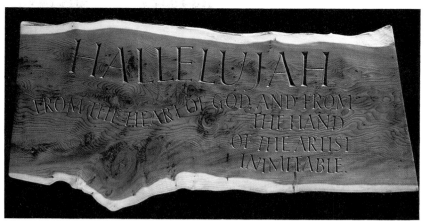

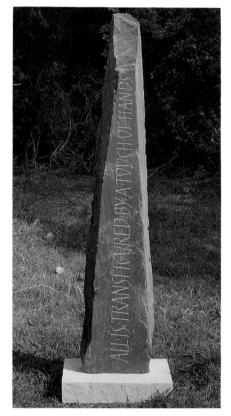

(Above)
'All is transfigured by a touch of hands'. Welsh slate menhir with incised inscription. Tom Perkins (UK), 110 cm (33½ inches) high. The words are taken from a poem called 'A Necklace of Stones' by Vernon Watkins

(Right) 'What is your substance, whereof are you made?' by William Shakespeare. A bread platter; incised quotation chosen by Peter Halliday. Martin Wenham (UK), 30 cm (11¾ inches) diameter. Cherry wood turned by Helen Michetschlager

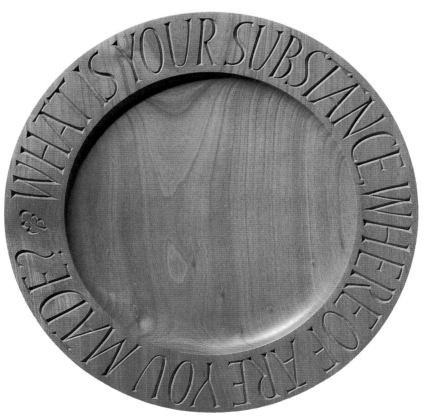

DRAWING OUT TYPEFACES

There may be times when you will need to enlarge and draw out some letters from a particular typeface. One easy method is to enlarge by photocopying and tracing, but this is only a very basic and crude way of working. If you have access to a process-camera typesetting facility, you can work direct without the need to draw. Nevertheless, there are times when drawing out is the answer – when designing a logo or letterhead, for example.

Enlarging a letter 'R'

To enlarge a letter from a typeface you will need to find a large version of the chosen style. Select this from type sheets, magazines or enlarge by photocopying.

Draw some guidelines about 3 cm (1 inch) apart on a piece of paper. Measure the width of the thick stroke *with great accuracy* by marking on the edge of some thin paper. Use a sharp, hard pencil. Measure how many times the thickness will go into the height, still with great accuracy. Divide the space between the guidelines into the same number of divisions and mark this measurement on the other side of the thin paper. This establishes the width of the thick stroke on the enlargement and can be used as a unit of measurement.

Using the enlarged measurement, draw two parallel lines at right angles to the guidelines to represent the thick stroke. Do not worry about the serifs at this stage.

Now measure the width of the original letter to the outside of the round 'bowl' (excluding the leg

The built-up-capital alphabet

BUILT-UP CAPITALS

FINISH WITH CORNER OF PEN

(Opposite)
'Flores Silvatici' with local names taken from *The Englishman's Flora* by Geoffrey Grigson. Hazel Dolby (UK), 35 × 25 cm (13¾ × 10 inches). From a book of pressed wildflowers. Gouache on Indian handmade paper. The very fine Roman capitals act as a delicate foil to the poppies

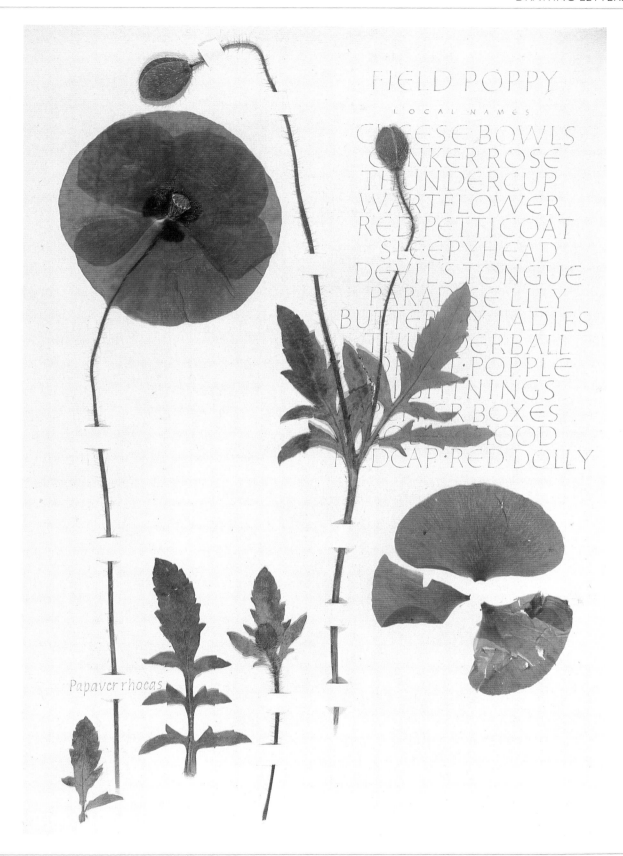

FIELD POPPY

LOCAL NAMES

CHEESE BOWLS
CANKER ROSE
THUNDERCUP
WARTFLOWER
RED PETTICOAT
SLEEPYHEAD
DEVILS TONGUE
PARADISE LILY
BUTTERFLY LADIES
THUNDERBALL
CORN POPPLE
LIGHTNINGS
PEPPER BOXES
HEADWOOD
HEADCAP RED DOLLY

Papaver rhoeas

and the serif); enlarge and make a mark on the enlargement to show the width. Follow this by measuring the position of the bowl's junction about halfway down the stem. Draw the outside of the bowl. Measure the thick stroke on the inside of the bowl; measure the thin strokes and draw the inside shape of the bowl. Draw these curves tentatively at first until you are confident that you have the correct shape, and then draw firmly. Add the leg by measuring the distance from the thick stroke and checking the thickness at right angles across the stroke.

Now measure and add the serifs. As they are all the same shape, when you are drawing more than one letter you could trace one and re-use the tracing whenever necessary.

Once you have drawn the letter out roughly, carefully rub out so that you can only just see the lines, and then draw in carefully and accurately. Use a ruler to straighten up the lines where possible. Make a careful tracing as described for drawing out the word 'ROMANS' on page 87.

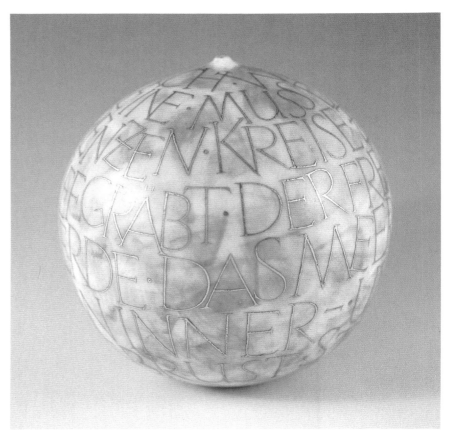

BUILT-UP PEN CAPITALS

Most calligraphic styles depend on the letter strokes being made with single movements, and, as we have seen, some letterforms may be drawn and painted. It is possible to use a pen form of capital letter which relies on making each part of the letter with more than one stroke.

The historical versions of built-up pen capitals are called versals, and are outlined and then filled in. These are based on corrupted versions of Roman capitals mixed with uncials, and are notoriously difficult to use well. They also have a tendency to look old-fashioned, and for this reason I do not often use the historical versions. I prefer to use the forms shown on page 90, which are based on Roman proportions but with the flexibility that direct writing will introduce.

USING LETTERS ON FABRICS

An attractive and rewarding way of working with letterforms is to use fabrics. The easiest and most basic way to work is to use fabric crayons or the felt-tips made especially for use on fabrics. Carry out experiments on old fabrics, such as old sheets or shirt material, as working on a surface that will move and stretch can be tricky. Tape the material down on a board as tightly as is necessary to prevent undue movement.

The choice of letter style needs care. Try to use a style which is adaptable and where precision and sharpness are less important, as crayons or felt-tips will never enable you to work with the sharpness of pen on paper.

Using these 'instant' methods is good for informal subjects such as T-shirts or temporary banners. For more special works – wallhangings or permanent banners, for example – using acrylic paints is a better idea. You will need to work on good-quality fabrics such as canvases and silks, depending on the size and scale of the project.

(Opposite)
'Globe form' by Mary White
(Germany), 16 cm (6¼ inches)
diameter. The wording is taken from a
contemporary poem by Margot Brust
about the eagle. The gold is meant to
suggest the majesty of the eagle
against the sky

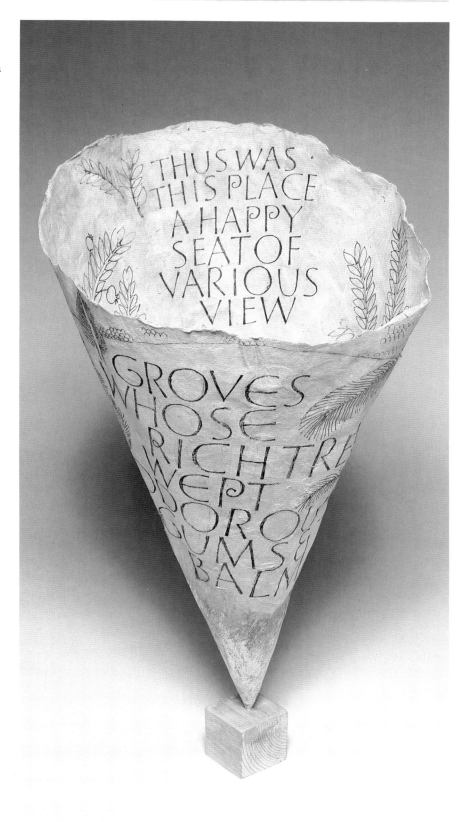

'Cone Pot 1' by Hazel Dolby (UK),
46 cm (18 inches) high. Layered Indian
paper, technical pens and transfer
gold. The quotation is from *Paradise
Lost* by John Milton

(Above)
'Chaos' by Mary White (Germany),
33 cm (13 inches) high. Porcelain. The
letterforms that Mary White has used
are a mixture of Roman skeleton
forms and some which are reminiscent
of built-up capitals. The piece also
rocks in the manner of a rocking chair

Machine-quilted cushion in satin by
Pat Russell (UK), 30 × 30 cm (12 × 12
inches). The letter 'K' is based on a
nineteenth-century typeface

CONCLUSION

You will probably have realized that the ways of working set out in this book are in the nature of starting points. There are many other things which can be done with letterforms which cannot be explored in a relatively short book like this one, and you might like to use your imagination to think of alternative ways of working. Once you know the basic 'rules', you can go on and make up your own. There are no limits except those that your own good taste or sense of design might dictate.

Teaching yourself to become critically aware is the best way of being more confident that what you are doing is going to look right. Firstly, don't be afraid of experimenting or of the consequent failures which may result; recognizing failures and learning how to improve on them is the most important part of self-education and the building up of confidence.

Secondly, train your 'eye' by being critical of every example of lettering and calligraphy that you see. This means being both positive and negative. It is no use only

being destructive in your criticism (which is very easy to do), but it is important that you should give yourself reasons for your comments, therefore being constructive.

Thirdly, look at and collect good examples of lettering of all kinds. There are many books available which show a multitude of good contemporary lettering works, as well as books showing the great examples from the past. The study of other people's solutions to design problems, their inspired interpretations or their sheer skill, is a further way of developing a critical eye. Remember: accept influences but never simply copy. Imitation is the sincerest form of flattery, but as an end in itself it is bound to be a sterile way of working.

The way in which any idea is conceived and developed is almost impossible to explain adequately. Intuition plays a fundamental role, but by its very nature depends on a mental approach which is not, on the face of it, logical. An intuitive response will develop when you have increasing confidence in your mastery of the basic techniques, so

that you can perform many of the technical functions as if they were second nature. There is no substitute for plenty of practice, but, as you have learned from this book, practice for its own sake is not the way forward. Always have a reason for practising, be it experimentation or finding a more comfortable pen hold; trying to improve spacing or learning a new letterform.

In our Western culture, the great ideas and works of literature, our religion and moral philosophy were upheld and transmitted by the educated scribes of the past. Although now, in the late twentieth century, there is a multitude of electronic and mechanical means by which we preserve our ideas and culture, there is still no substitute for the personal response which calligraphy allows us to make to language and literature, on many different intellectual and artistic levels. Calligraphy is both art and communication. It can contribute to our modern culture by combining literature and art, and in doing so, makes each more significant.

INDEX